ABDULNASSER GHAREM

First published: 2011 by Booth-Clibborn Editions
in the United Kingdom | www.booth-clibborn.com

Editors: Edward Booth-Clibborn & Stephen Stapleton
Assistant Editor: Miriam Lloyd-Evans
Copy Editors: Julia Booth-Clibborn & Ananda Pellerin
Design: One Darnley Road

Text: Henry Hemming© 2011

A cataloguing-in-publication record for this book is
available from the publisher.

ISBN: 978-1-86154-324-0
Price: $50.00/£30.00

www.abdulnassergharem.com

Produced by Edge of Arabia

ABDULNASSER GHAREM

ART OF SURVIVAL

Text by Henry Hemming

Booth-Clibborn Editions

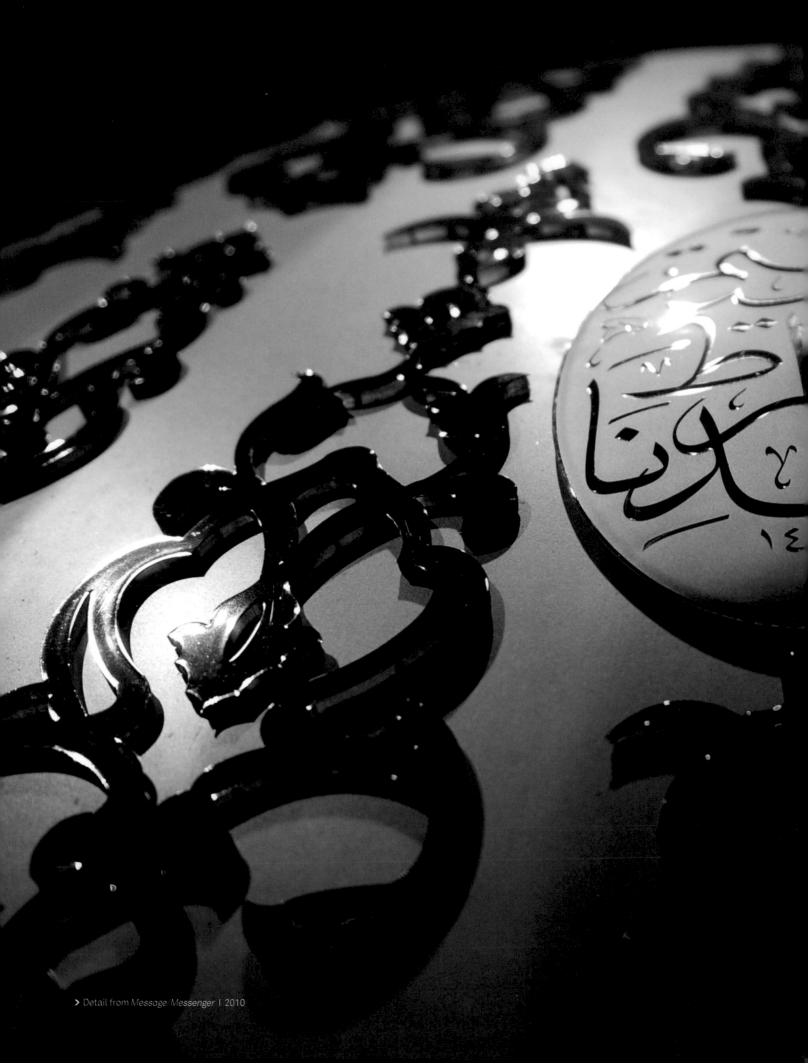

> Detail from *Message/Messenger* | 2010

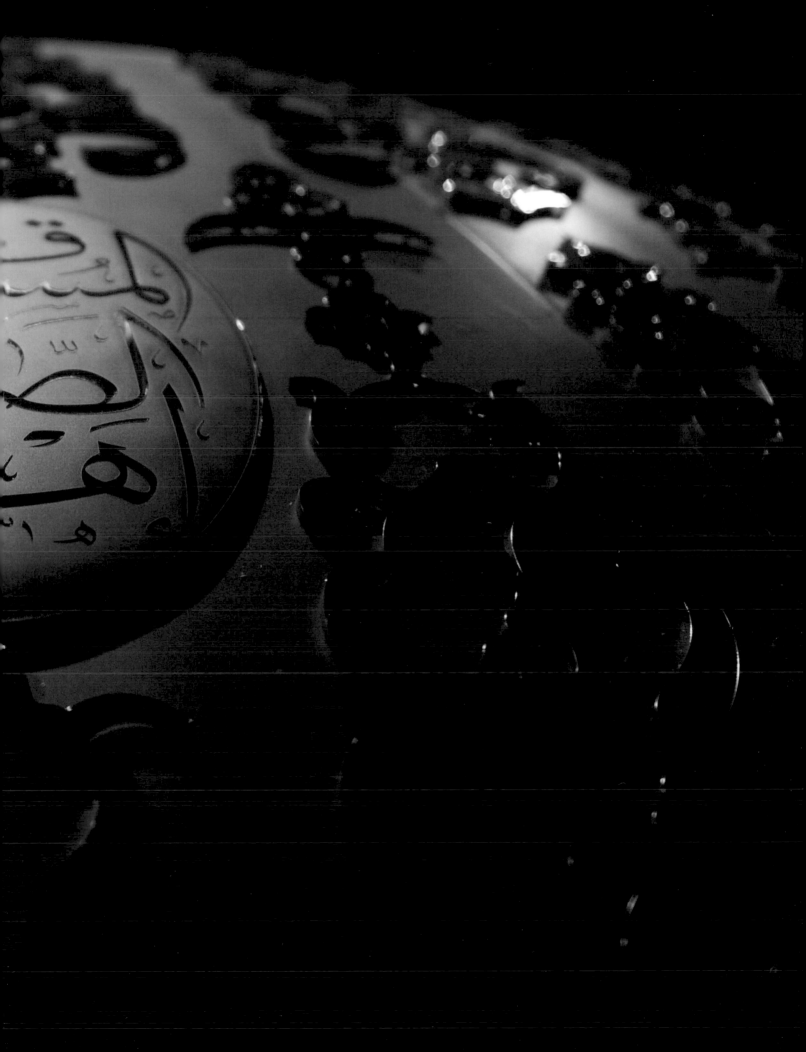

CONTENTS

Detail from *Concrete II* | 2009

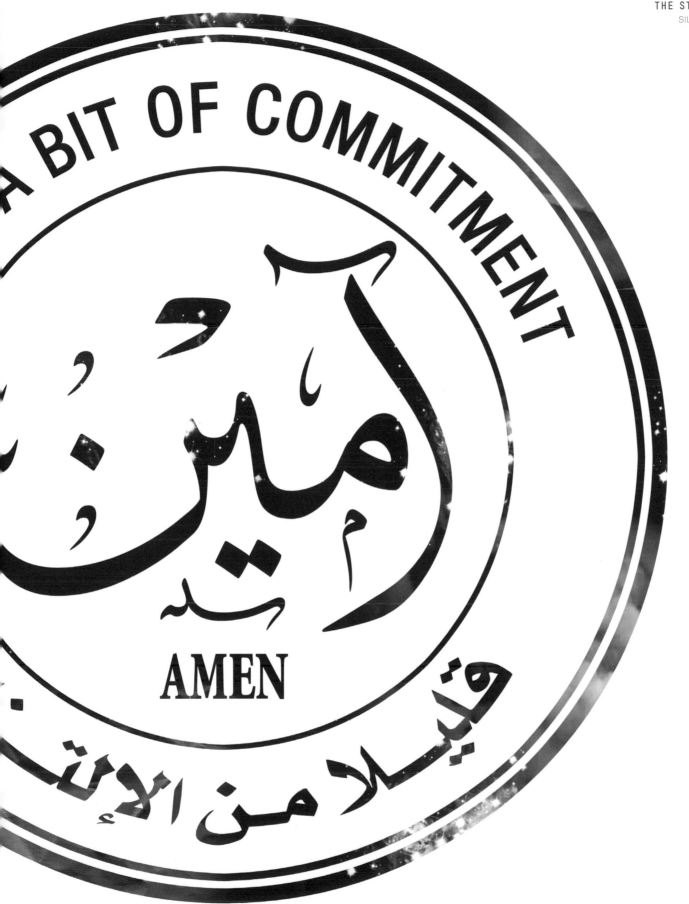

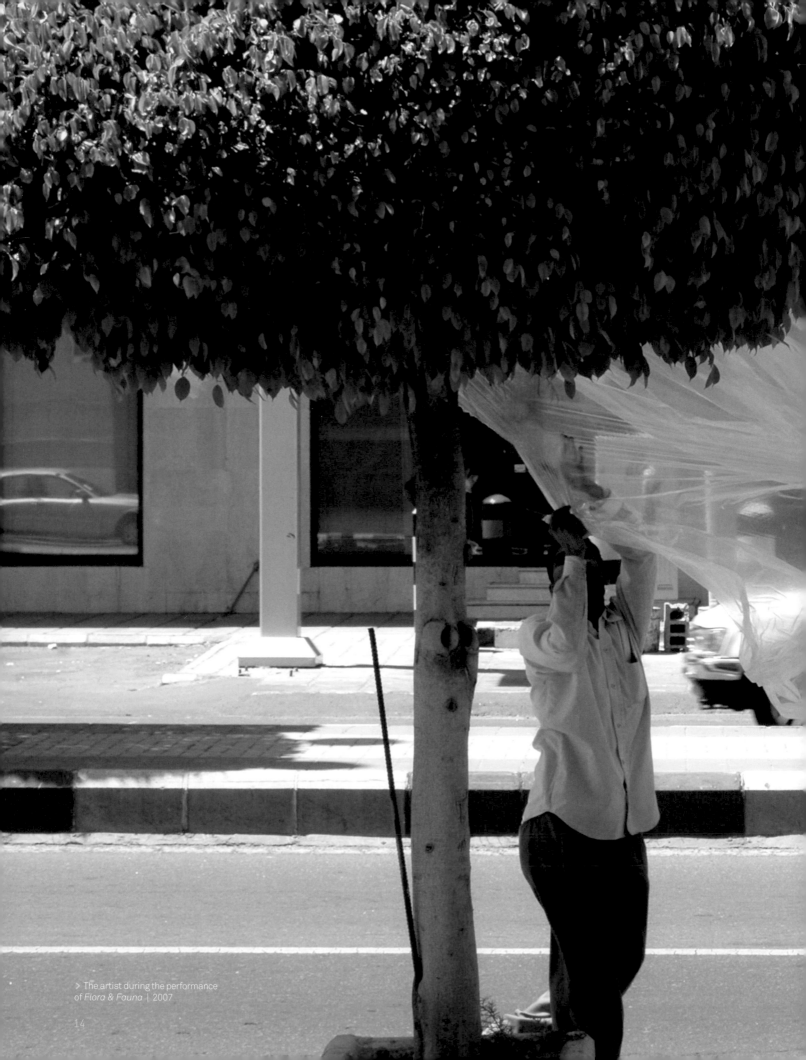

> The artist during the performance
of *Flora & Fauna* | 2007

14

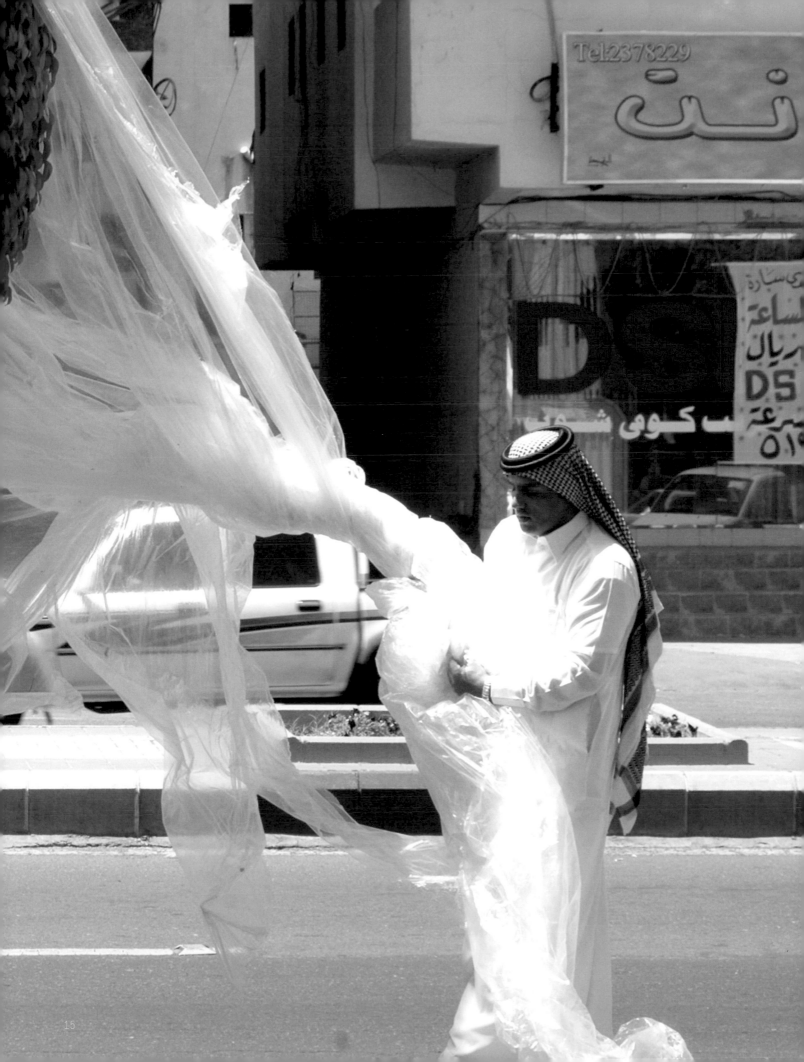

MESSAGE/ MESSENGER

It was standing room only as the auctioneer took to the rostrum. He was a bolt of a man with hands that danced, and on that evening he wore a pale purple tie. He was set to preside over the first major auction of 2011 for Christie's Dubai, on a night that would make headlines around the world. One of the works set to go under the hammer was by the Saudi artist Abdulnasser Gharem...

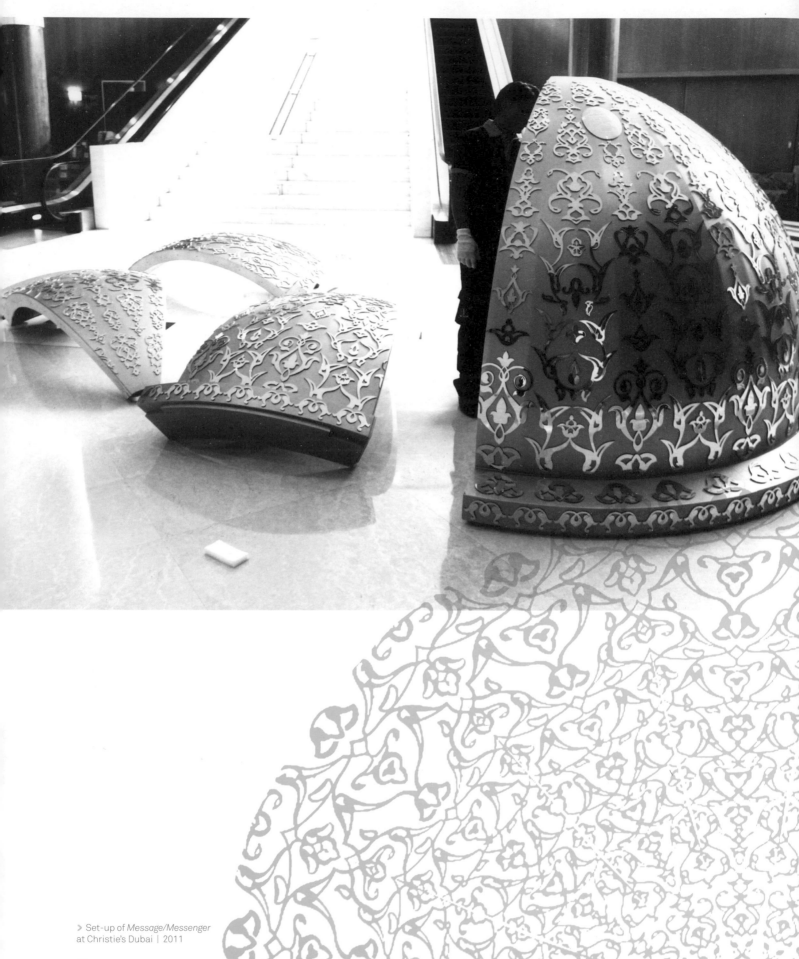

> Set-up of *Message/Messenger*
at Christie's Dubai | 2011

This is, perhaps, an unusual place to begin an artistic biography. Few artists attend auctions. Many will see them as remote points on the creative continuum: commercial arenas in which a work of art that was once vital and full of protean possibility has become little more than stock. But an auction also provides a degree of dislocation, and this can be useful. For most of what follows Abdulnasser Gharem will be centre-stage, but on that night in Dubai he was an outsider. Gharem lives and works in Saudi Arabia, a country without a recognised contemporary art infrastructure, and as such he did not benefit early on in his career from the type of formal training enjoyed by most of the blue-chip, international artists whose work was also for sale that night. Nor did he have the selling pedigree of these other artists. This was only the third time Gharem had been involved in an auction. Here was a man who had sold his car in order to finance the piece he had put forward that night, a sculptural installation called *Message/Messenger*.

And yet, Gharem's work had been singled out in the Christie's press release as "the highlight of the sale," and had dominated the press coverage in the lead-up to the auction.

But he would make no money that night. Again, we find him at a remove. Gharem had agreed to donate the proceeds from the sale of *Message/Messenger*—if there were any—to the social enterprise Edge of Arabia. This money would "go toward nurturing a new generation of artists and curators in Saudi Arabia," as the organisation's Creative Director Abdullah Al-Turki explained. This mattered to Gharem. "Growing up, I never received a proper artistic education," he says.

"While I am self-taught, and I relish that, not having this education has set me back many years. I don't want the next generation in Saudi Arabia to experience the same thing."

"Ladies and Gentlemen," the auctioneer began. "I'd like to welcome you all to the Christie's sale of modern and contemporary Arab, Iranian and Turkish Art. For those of you who have not been here before..."

Before him was a cavernous, air-conditioned ballroom. It contained most of the *beau monde* of Middle Eastern art. Those who couldn't make it were either watching online or had the ear of an in-house telephone bidder. Alongside Emiratis, luminous in their *thobes,* there were women in leopard-skin shoes clutching sale catalogues, as well as Arabic, Iranian and European collectors, ex-pats in open-necked shirts, porters, dealers, waiters, curators, a scrum of journalists and on the periphery, the mass of hangers-on that you tend to find at major auctions.

Only six years earlier an event like this was unheard of anywhere in the Gulf. At the dawn of the twenty-first century, just as this part of the world contained no international auction houses, "there were hardly any galleries or museums showing contemporary art in the region," recalls Ali Khadra, editor of Canvas, the leading magazine on Middle Eastern art and culture. "The local art scene was negligible and particularly so in the Gulf states." He goes on: "the creativity of the Middle East was somehow stultified, almost dormant."[1]

Things had changed since then, and they had done so dramatically. The ownership and display of contemporary art had become a grounding element

> Sheikha Mozah Bint Nasser Al Missned of
Qatar with *Message/Messenger*. Edge of Arabia
Istanbul | 2010

> *Message/Messenger*, Christie's Dubai | 2011

> Auctioning Lot 60: *Message/Messenger* | 2011

in the self-perception of most Gulf states. By 2011, an epic programme of museum-building was underway, and it was on a scale that had not been seen anywhere in the world since the mid-18th century. In Qatar, Abu Dhabi, Sharjah, Dubai and Bahrain, some forty museums were under construction, including local incarnations of the Louvre and the Guggenheim, designed by architects such as I. M. Pei, Zaha Hadid, Jean Nouvel and Frank Gehry. For Sheikha Mai, the Minister of Culture and Tourism for Bahrain, this was "a natural step in the ongoing process of our state-building."[2] Just as billions of dollars had been poured into this "cultural arms race,"[3] the market for contemporary art throughout the Gulf had been transformed.

The first few lots went fast. The bidding was steady rather than frenzied, but with time the auctioneer hit his stride and the room warmed up. After an hour the sale was ticking over well. Individual records were being broken, and the crowd at the back of the room was reaching critical mass. At last a photograph of Gharem's *Message/Messenger* flashed up on an overhead screen.

"Ah," said the auctioneer, turning towards it, "the first of the Saudi works."

Message/Messenger is a three-metre-wide wooden dome veneered with candescent, burnished copper. Limpid Arabesques curl towards the summit between roundels that read "guide us to the right path." The dome has the proportions and colouring of the Dome of the Rock in Jerusalem, the shrine at the heart of the Temple Mount, or Haram Al-Sharif, the site revered by followers of the three Abrahamic faiths. Yet it does not sit square on the floor. Instead it is rigged up to look like an animal trap. Most of the structure is kept off the ground by a *hilal*, the tower of spheres topped by a crescent moon that often appears on the dome of a mosque. Attached to the *hilal* is a luxurious golden rope. One tug and— BANG!—the whole thing comes crashing down. The key to this piece, however, is hidden away beneath the hemispherical dome. There, lit by a shaft of light, sits a taxidermy dove.

Like so much of Gharem's work, the genesis of *Message/Messenger* appears to date back to his childhood. "Rich people in Saudi Arabia keep horses, everyone else catches pigeons or doves and keeps them instead," he explains. Gharem is tall and broad with amber-coloured eyes. He has a deep, melodious voice. "It's easy. You set up the trap using a basket or any kind of dome, and you leave out some water and sugar. Soon you have a bird. Keep the bird in that trap for twenty days and it knows that this is its home. It will not leave you."

The precarious nature of *Message/Messenger* is both thrilling and unsettling. The piece strains under its own gravitational potential; it is the sculptural equivalent of a question-begging phrase. The hulking size of the dome positions the dove as not only the victim of this rudimentary trap but the bait. Perhaps there is another target here – you, me, the viewer. We are drawn in by the pared-down promise of peace and spiritual salvation, but when we least expect it—BANG!—the leviathan of organised religion traps us and we can no longer see the light.

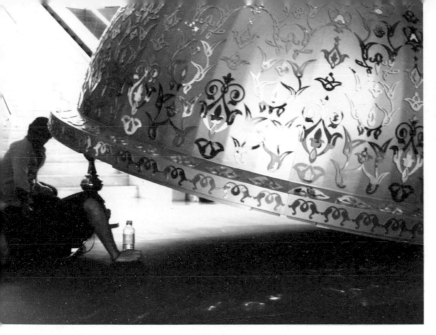

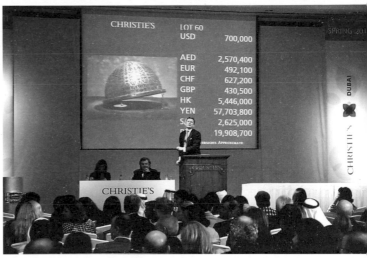

"I can start the bidding for *Message/Messenger* at fifty thousand dollars," the auctioneer began breezily. Before him, a series of paddles went up.

"Fifty-five thousand. Sixty thousand, seventy thousand is here and I'm selling. At seventy thousand dollars."

It was over in a flash. Gharem had done it. He had made enough money to buy back his car and donate a small sum to Edge of Arabia. At that moment another bid came in.

"Eighty thousand dollars to the gentleman standing," said the auctioneer, his face softening into a smile. It was as if he had seen something that piqued his curiosity.

"Eighty thousand dollars," he repeated, cocking his head to one side. "Will you give me ninety sir?" He swung his body forward. Questioning furrow. Flickering grin.

The paddle went up. The price advanced haltingly to $120,000, at which point the room fell flat. The auctioneer's voice began its familiar descent towards the close of the sale. He scanned the room as if to conclude, before interrupting himself as a fresh bid came in. Then another, and another, and another one after that.

The conversation between the auctioneer and his audience had acquired a frenzied momentum. The price tore up to $180,000. It kept going, hopping forward in increments of $20,000 and $30,000, the auctioneer's voice urgent and consistent like machine-gun fire.

The bids broke the $300,000 mark. Next the $400,000 mark. The audience was rapt.

"We couldn't believe it," says Miriam Lloyd-Evans, an assistant curator at Edge of Arabia, who had helped to install *Message/Messenger* in Christie's Dubai.

"To see it get that far was not only exhilarating but a huge relief, given how much effort Abdulnasser had put into making the piece."

"Give me one more," the auctioneer continued. "And I'm selling at four-hundred and fifty up front." Another bid slipped in. "At four-eighty. Give me half a million," he challenged the room. Quick grin.

"Yes! Five hundred thousand dollars is bid."

A round of applause broke out—more of a nervous release of energy than an outright celebration—only to fade away as the bidding started up again. The price continued to soar.

"At 700,000 dollars," said the auctioneer at last. "700,000. Are you all done? Definitely all done. Thank you so much for the bidding. Here it is. In the second row."

The auctioneer gripped the gavel high on the stem. With his right hand he aimed his trademark flourish at the winning bidder before powering down with his left. BANG!

The room erupted. It could have been the end of a Hollywood film. The crowd cheered and whooped. A surge of applause filled the space and even the auctioneer was moved to join in.

Isabelle de la Bruyère, Director, Christie's Middle East, later described this as "one of the most memorable moments since we first started our auctions in Dubai."

"We were completely euphoric and in total disbelief," says Aya Mousawi, another Assistant Curator at Edge of Arabia. "It was like an amazing secret we'd known had suddenly gone public. In those few moments, it felt as if Abdulnasser had opened a new chapter in the history of Saudi contemporary art."

30 M 20 10 0

ح مؤسسة تعليمية

الغارم

الأخير في لندن بعنوان «تطور الإنسان» يعالج علاقة الإنسان والنفط وتأثيرها. العمل يعرض للبيع بسعر يتراوح ما بين 22 ألفا و28 ألف دولار.

ومن أعمال الفنان أيمن يسري تعرض الدار عمل «محارم» المحمل بمعان كثيرة ومتشابكة وحميمية في نفس الوقت لها انعكاسات بالنسبة للهوية والثقافة. العمل يعرض للبيع بمبلغ يتراوح ما بين 20 ألفا و25 ألف دولار.

ومن أعمال المصورة السعودية منال الضويان يضم المزاد ثلاثية «غرك زمانك لكن الزمن غدار» التي قدمتها المصورة في معرضها الأخير في دبي. ومن خلال الثلاثية نستمع إلى محادثة مرئية بين سكان المدن وفضائها. منظومة الضويان يقدر لها سعر ما بين 15 ألفا و20 ألف دولار أميركي.

كذلك يقدم المزاد عملا للفنانة مها ملوح التي تستكشف في لوحاتها المسلمات في حياتنا عبر تصوير مجموعة من الأغراض الحياتية التي تظهر للناظر وكأنها صورة أشعة مأخوذة من إحدى نقاط التفتيش في المطارات. الأشياء موضوعة بعفوية وفوضى لا تنظيم هناك فهي أشياء لا يربط بينها سوى الإنسان الذي يحملها ولا يمعن النظر فيها، على الرغم من أنها جزء من حياته. ملوح المقيمة بالرياض بدأت عملها الفني عبر التصوير ومن إنتاجها يعرض المزاد عملا بعنوان «المستور» ويقدر له سعر يتراوح ما بين 5 آلاف وسبعة آلاف دولار أميركي.

الفنان السعودي سامي التركي المنضم حديثا إلى مجموعة فناني «حافة الصحراء» يشارك في المزاد بعمل فوتوغرافي بعنوان «مرحبا» الذي شارك به من قبل في معرض «حافة الجزيرة العربية» بإسطنبول، ويقدر له سعر ما بين 5 آلاف وسبعة آلاف دولار أميركي.

ومن جانبها، تقول إيزابيل دي لا بروير، مديرة الدار بالشرق الأوسط: «في أعقاب نجاح معارض (حافة الجزيرة العربية) في لندن وفينيسيا وبرلين وإسطنبول والتحضير لمعارض خلال الأشهر المقبلة في دبي وجدة، قام الفنانون

يوميات الشرق

الشرق الأوسط

بالتضامن مع دار «كريستيز» بدبي

فنانون سعوديون يعرضون أعمالهم في مزاد لصا

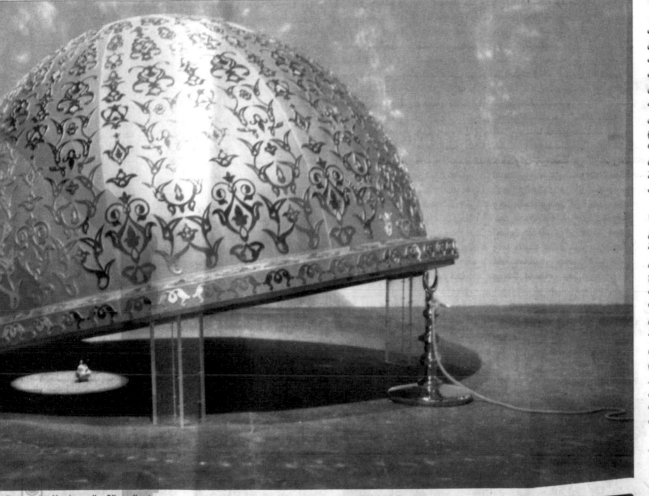

عمل «الرسالة - الرسول» للفنان عبد الن

لندن: عبير مشخص

حـيـن تـعـلـن دار مـزادات عالمية عن بيعها لأعمال لفنانين سعوديين في مزادها المقبل فذلك ليس بالخبر الجديد، فهي ليست المرة الأولى التي تظهر فيها أعمال لفنانين سعوديين في المزاد العلني، وليست المرة الأولى التي تتولى فيها دار مـزادات عالمية تنظيم ذلك، فدارا «كريستيز» و«سوذبيز» عرضتا أعمالا لفنانين سعوديين على مدى الأعوام القليلة الماضية، ولكن الجديد هنا أن تعرض تلك الأعمال للبيع بغرض خيري.

فقد أعلنت دار «كريستيز» أنها ستقدم في مزادها المقبل في دبي في 19 أبريل (نيسان) المقبل ستة أعمال لفنانين معاصرين للبيع على أن تخصص عوائد البيع لصالح البرنامج التعليمي الذي يتبناه معرض «حافة الجزيرة العربية» للفن السعودي المعاصر. الأعمال التي تعرضها «كريستيز» لستة فنانين من المؤسسين للمعرض والمشاركين الرئيسيين فيه ومنهم عبد الناصر الغارم وأحمد ماطر ومها ملوح وأيمن يسري ومنال الضويان وسامي التركي، وتهدف المجموعة إلى جمع مبلغ 150 ألف دولار عبر المزاد.

وحسب تعبير عبد الله التركي، المشرف الفني لـ «حافة الجزيرة العربية»، فإن البرنامج التعليمي هو جزء مصاحب لكل المعارض التي أقامتها مجموعة فناني «حافة الجزيرة العربية». ويقول: «مع كل معرض كان هناك برنامج تعليمي مصاحب، ففي الرياض كان لدينا برنامج لطلبة الجامعات وفي دبـي أقمنا ورشا تعليمية مع الفنانة منال الضويان وفي برلين كان هناك مؤتمر في الجامعة حضره طلبة الفنون».

ويضيف التركي أن «هذه هي المرة الأولى التي يتم فيها بيع الأعمال الفنية بغرض جمع المال لدعم المعارض القادمة والبرامج

ON THAT NIGHT
LT-COL GHAREM
MADE HISTORY

It was unclear whether the applause that night had been directed towards Dr Farhad Farjam, of the Farjam Collection, the new owner of *Message/Messenger,* or, in a more abstract sense, at Abdulnasser Gharem.

Abstract because he was not there. At that moment Gharem was at work hundreds of miles away in Riyadh, the capital of Saudi Arabia. As a Lieutenant-Colonel in the Saudi Arabian Army, it is not always easy to take time off work.

On that night Lieutenant-Colonel Abdulnasser Gharem made history. The final price paid for *Message/Messenger,* including the buyer's premium, was $842,500, almost a hundred times more than the highest price he had previously commanded at auction. It was one of the largest sums ever paid for a work by a living Arab artist. In the space of seven minutes, this soldier from southern Saudi Arabia who had failed to secure a place to read art at university, an outsider with no formal artistic training beyond art lessons at secondary school (in a class that included two pupils who went on to be 9-11 hijackers), had become one of the most celebrated artists in the Middle East.

Missing seminal moments in his artistic career was by now a recurring theme. Several years earlier Gharem had been unable to make the opening night of his debut exhibition in Dubai because he was busy commanding his troops in action on the Yemeni border. For any artist your first exhibition leaves an indelible mark, yet what had happened that night in Dubai was different. It changed the trajectory of Gharem's career and quite possibly the direction of Saudi Arabian contemporary art.

The fact that Gharem could not be there introduces the most obvious paradox that he embodies. He is a soldier and an artist. Fine, you might say. Alaa Al-Aswany, author of *The Yacoubian Building*, is a dentist and a writer. Peter Paul Rubens was a diplomat and an artist. Marcel Duchamp was also a chess Grandmaster. The idea of an artist maintaining two careers like this is not in itself new. What gives it traction here is the conflicting nature of Gharem's art and his military career. In his work he challenges notions of authority, obedience and intellectual deference, yet he does so as a senior figure within the Saudi Arabian Army.

This is all the more relevant when you consider the historical context of the Christie's sale. It took place in April 2011 during a period already referred to as the Arab Spring, in which the Middle East had been stunned and often inspired by a string of upheavals and protests. The outcome of almost all, from Tunisia and Libya to Egypt, Syria, Jordan, Iraq, Yemen, Oman and Bahrain, appeared to pivot on decisions made by soldiers. In each of these situations soldiers had been forced to make similar calculations: having been given orders to disperse unarmed protesters, should they follow these instructions or question them? What was "the right path," as Gharem put it on the side of *Message/Messenger*?

In the deluge of reports that followed the sale of this piece you could be forgiven for assuming this was a breakthrough moment for an artist at the start of his career. Really, it was a milestone.

To reach this point Gharem had endured an arduous and at times quixotic journey. On the one hand he had been praised to the sky by the likes of *Rolling Stone*

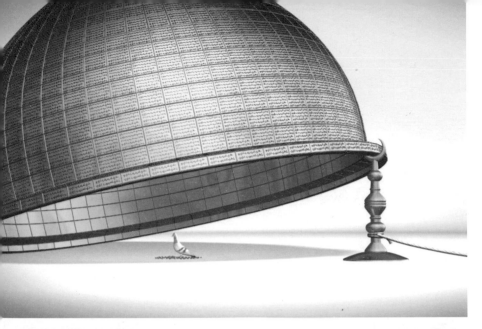

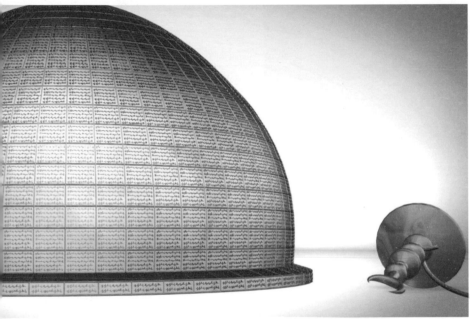

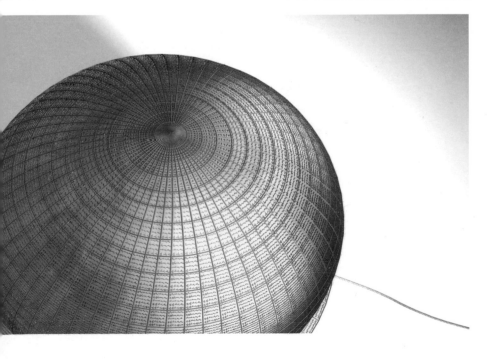

32 Features

Saudi Arabia

What's the difference between a soldier and an artist?

Nothing at all, if you're Abdulnasser Gharem, lieutenant-colonel in the Saudi Arabian army and rising star conceptualist

Abdulnasser Gharem was recently described—by Robin Start, of London's Park Gallery—as "without doubt the leading conceptual artist in Saudi Arabia today", yet for six of the last seven years he has struggled to find a platform for his work. Could one reason be that he is also Lieutenant-Colonel Abdulnasser Gharem of the Saudi Arabian Army? Or might it simply be that life as a conceptual artist in Saudi Arabia will always be a difficult position to occupy? Whatever the case, his lack of recognition seems about to become a thing of the past.

From 17 January-10 March, Gharem has his first solo exhibition, "Restored Behavior", at XVA Gallery in Dubai; and from 23-26 January his work featured in the touring "Edge of Arabia" show at the 2010 Global Competitiveness Forum in Riyadh, Saudi Arabia, the annual gathering of business and political leaders and other invited speakers, that this year will feature keynote speeches from MoMA director Glenn Lowry and former UK Prime Minister Tony Blair, among others. For the latter Gharem has contributed a portrait of the conference's patron, HRH King Abdullah of Saudi Arabia, while the former will show early work based on site-specific performances and installations, and more recent pieces to do with authority, the spread of concrete, and the accoutrements of bureaucracy in his native country. The content of and contributors to "Edge of Arabia" can and will vary; however, Gharem is one of the exhibition's "core contributors" who will always have work on show.

Born in 1973 in Khamis Mushait in the Hejaz region of Saudi Arabia, Gharem had a conventional, middle-class upbringing. However, he was, and remains, a compulsive autodidact. While training to be an army officer he devoured everything he could find on politics, philosophy, history and, in particular, art. At one time such material would have proved hard to come by, however, Gharem's intellectual flowering in the mid- to late-1990s coincided with the growth of the internet. Once he started to gain knowledge, the challenge became how to apply it.

Saudi Arabia may boast the world's most advanced facilities for the production of

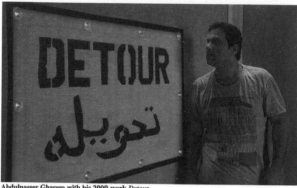

Abdulnasser Gharem with his 2009 work *Detour*

petroleum, but its fine art infrastructure is meagre. At the time you could count on the fingers of one hand the number of contemporary art galleries; there were no fine art colleges, art journals or independent curators, nor museums, foundations, institutions, art fairs, auctions or biennials devoted to contemporary art. Abha's Al-Miftaha Artists' Village was an exception. More of a part-time artists' colony than a training college, this is where Gharem enrolled part-time in 2003.

At Al-Miftaha he met Ahmed Mater, a brilliant, 18-year-old trainee doctor. Both were fascinated by the possibilities of western conceptual art and together they began to hoard books on the subject and produce more experimental work.

This culminated in "Shatta", a group show at Jeddah Atelier in 2004. Artistically it was a success, but they sold nothing. Gharem had reached what, for many Middle Eastern artists, is a familiar impasse. With insufficient demand for conceptual work many move to a foreign cultural capital, such as Paris, London or New York.

"Move abroad?" says Gharem. "No way. My art is related to people living in Saudi Arabia. I am living in one of the most interesting countries in the world. Why move? I want to show what has happened in this country. This is my mission."

It's a forceful point in a country where journalistic freedom is limited, made more so coming from the mouth of a serving soldier. A good example of the kind of social commentary found in Gharem's work is *Manzoa*, a day-long performance in which he staged recently at Jizan, southern Saudi Arabia. The houses here had been recently purchased by the government and were daubed with the word manzoa, meaning "about to be demolished". Yet the inhabitants had spent the compensation they had received on qat, the chewable narcotic plant that is much abused in neighbouring Yemen. Gharem covered himself in the word "manzoa" and recorded a day moving among these people, playing football with them, eating with them and hearing their stories.

"I know this will not change their situation, but I also know the power of the image. It is important to show how these people are living. Otherwise we don't see them. Be interested in these people! That's what I am saying."

Just as he will not leave Saudi Arabia, Gharem has no plans to leave the military. But how can he possibly combine life as Saudi Arabia's leading conceptual artist with a career in the army? For Gharem the two dovetail neatly. As a lieutenant-colonel he has *wasta*, or prestige. He drives a leviathan of a car, wears a uniform and knows how to speak to the soldiers manning roadblocks. "This is important. It gets me into places that would be off-limits to a civilian in a small car. Once I'm in these places, I can make art."

There is also his desire to remain, as he puts it, "among people. The one thing I fear is running out of ideas, and this will happen only if I leave the country, or I stop talking to people." Gharem's subject-matter is bureaucracy, religion, the spread of concrete, barriers, poverty, ecology, the production of oil, the use of water; by remaining in the army, he argues, he maintains a far more informed perspective than he would marooned in a studio.

However in Saudi Arabia, the possibility of censorship is a constant. Gharem's contribution to the original "Edge of Arabis" exhibition that opened in October 2008 at London's School of African and Oriental Studies was meant to include *The Path*, a photograph of an installation he created on the remains of a collapsed bridge. In 1982, those living beneath it heard about an imminent flash-flood and took shelter on the bridge along with their vehicles and livestock. The flood washed away the bridge and its occupants, killing most of them.

For *The Path*, Gharem wrote the word Al Siraat several thousand times over the concrete stump of the bridge. The finished text ripples like water. Al Siraat means "the path" or "the way"; it refers to the choices you make in life, in whom or what you place your trust and the need to follow the straight path. The word can also refer to the Day of Judgement and the bridge that leads to Paradise. During the months leading up to the opening of the exhibition in London it was suggested that the work could be seen as religiously insensitive. It was removed.

Gharem produced another work, involving tens of thousands of rubber Arabic letters, numbers, numeric functions and one or two

English letters, the kind you find on official stamps. Onto this he placed an abstract design. This was thought to be symbolic of the World Trade Center in New York, and with just days to go Gharem was told to alter it. The previous evening, photographs from his *Manzoa* installation, also set to be part of the display, were removed from the gallery and hidden.

Other artists would have walked away. To his credit Gharem not only stuck with the exhibition but saw an artistic contingency in all this. He had an oversized rubber stamp built in Saudi Arabia and brought it with him to the exhibition opening. Originally entitled *Restored Behavior*, now retitled *The Stamp*, it takes two people to lift, is just under a metre tall and over its business end has a series of loops and whorls that read, in Arabic, "show more commitment" and "Amen". On his arrival, Gharem inked it up and charged it at the walls of the gallery as if it were a medieval battering ram. You could say the exhibition was now authorised. For once Gharem was the author of this authority.

At no point had Gharem broken a British or Saudi law, nor had he challenged an established taboo or religious convention. Visual censorship in Saudi Arabia, such as it is, is mostly influenced by custom, norms and recent statements by local sheikhs or members of the royal family. It is rooted in personal judgement, and, crucially, it shifts with time.

When a reduced version of "Edge of Arabia" was shown at Palazzo Contarini dal Zaffo in Venice, coinciding with the 53rd Biennale in 2009, Gharem's contribution was a video based on *The Path*. Dr Abdulaziz Al-Sebail, the Saudi Arabian deputy minister of culture, came to see it. His reaction was emphatic: he watched it back-to-back seven times and later told Gharem it was one of

> **❝ *Move abroad? No way. I am living in one of the most interesting countries in the world. Why move?* ❞**

the most powerful things he had ever seen. Al-Sebail now considers Gharem to be "one of the leading artists in Saudi Arabia and someone we [at the ministry of culture] believe in very much."

2009 was a good year for Gharem. Not long after Al-Sebail saw *The Path* in Venice, a different version was purchased for a joint collection run by London's British Museum and Victoria and Albert Museum (with support from The Art Fund). He participated alongside Mona Hatoum in "Taswir", a group exhibition in Berlin in November, and last April he registered his first sale at Christie's Dubai. "Most Saudi collectors now see Gharem's work as very, very important," confirms Robin Start.

Following the accession of King Abdullah in 2005 there has been a gentle shift within Saudi Arabia. The understanding of the utility of art has changed. There is now a rehabilitation centre for failed suicide-bombers outside Riyadh that uses art

Gharem's site-specific work *The Path*, 2007. A related video work has been jointly purchased by the British Museum and the V&A

as a form of therapy, and there is a concomitant emphasis on promoting Saudi Arabian contemporary art internationally. This is part of the reason why the Global Competitiveness Forum will feature work by Gharem, among others.

According to William Lawrie, head of sales, International Modern and Contemporary Art at Christie's Dubai: "The work of Gharem and others has certainly forced buyers, collectors and dealers in the Gulf to take a fresh look at Saudi Arabia." What has consistently set Gharem apart is his status as "a kind of 'outsider' within the art scene of the Middle East, a conceptual artist dealing with purely local issues", as collector Rüdiger Weng puts it. Now, it seems, this outsider is being welcomed onto the main stage.

Henry Hemming

❏ **Edge of Arabia** will tour to Art Dubai, 17-20 March, the Berlin Biennial, 11 June-8 August, and Contemporary Istanbul, 25-28 November. Further dates for 2011-2014 are expected to include New York, Miami, Paris, Beirut, Sharjah, Kuala Lumpur, Singapore, Tokyo, Sydney and Amsterdam, final details to be announced. www.abdulnassergharem.com

and *Le Figaro,* as well as Saudi national newspapers including *Al Riyadh* and Saudi state television, which ran a 45 minute-long interview with him following the sale of *Message/Messenger*. There had also been sustained criticism, and this had had a negative impact on his personal life.

The point of this book is to bring Abdulnasser Gharem's journey to life. Over the coming chapters we will move from a remote village high in Saudi Arabia's Al-Sarawat mountains, with the country poised to enter a period of intense religious conservatism, through to the frenetic, bright-lit drama of an international art auction thirty-eight years later. How did Gharem reach this point? What sacrifices did he make, and what does this tell us about him, the society in which he operates and the fluid, hidden lines beyond which he must not stray? What does it say about the future of Saudi Arabia?

Gharem's has been a journey full of detours. While the route has changed repeatedly and unexpectedly—which is a good thing, for here is an artist who flourishes in adversity—his destination has remained constant. He strives to inspire the people around him to question their surroundings.

As Aarnout Helb of Amsterdam's Greenbox Museum has put it, what sets Gharem apart is "his confidence in art itself as a way of changing people's thinking. It is art for life and not a design for a life with art." While Gharem takes much of his visual inspiration from his life in Saudi Arabia, his work formulates a global agenda. His practice is geared towards an exploration of how to enable change and, crucially, how to live with the consequences. What follows is as much about art as it is a reflection on the art of survival.

THE ROAD TO SHATTAH

Abdulnasser bin Gharem bin Ajlan Al-Ajlan Al-Amri grew up during an unusual period in the history of Saudi Arabia. He was born in 1973, the year that King Faisal decided not to sell oil to the United States. Financially, it was an astute move. The price of oil shot up and the petrodollars began to pour in...

BORN IN 1973, THE YEAR THAT KING FAISAL DECIDED NOT TO SELL OIL TO THE UNITED STATES

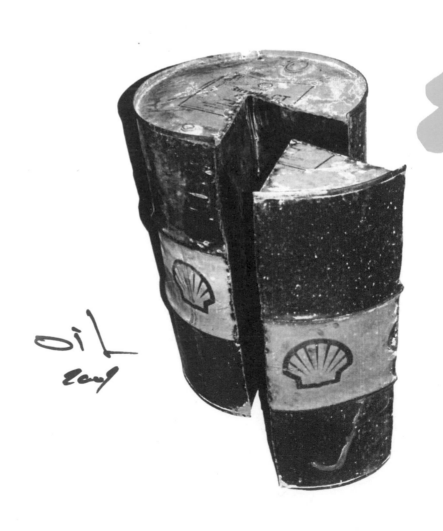

> Detail from *Oil*, mixed media installation I 2009

The modernisation that followed was lightning-fast. By the end of the 1970s Saudi roads were filled with cars. Suddenly there were televisions in many if not most homes. More women were in work. There was more English being spoken, and on the radio and in cafés you heard western music for the first time.

Many Saudis saw these developments as *bid'ah*, irreligious innovations, and by the start of the 1980s the backlash had begun. This took the form of a Salafi religious revival that became known as the *Sahwah*, or Awakening. Cinemas were soon a thing of the past. 'Family sections' appeared in coffee shops and restaurants throughout the country that led to greater segregation of the sexes. It was no longer considered appropriate for women to drive, and their job opportunities narrowed. Clothes became more conservative for both sexes, and religiosity was incentivised with cash prizes offered to those who could recite the Holy Qur'an by heart. Qur'anic printing presses went into overdrive, and billions of dollars were pumped into bolstering religious institutions such as the *Mutawa*, the religious police.

Gharem spent the first seven years of his life in a mountain-top village before moving to Khamis Mushait, a provincial military town near the border with Yemen. His family made this move just as the *Sahwah* kicked into gear.

"Khamis Mushait is more like a village than a town," he explains. "It is a very tribal society. Very traditional. Everyone belongs to one of the large families."

With this comes a certain watchfulness. Your reputation is more fragile in a society like this. You go out of your way to preserve it and avoid any breaks with convention. Stick to the centre ground, he learnt, choose the right path.

At an early age Gharem began to understand the importance of having two 'faces': one for the community, one for yourself. If you experiment or develop unusual ideas—as he would go on to do—it was best to do so in private. You certainly did not allow this to happen at school, where the *Sahwah* was most keenly felt.

"I remember the man who was meant to teach us English," Gharem says. "He'd just say to us, 'guys, you don't need English... Let's read the Holy Qur'an instead.' So that's what we did. With other lessons, the same thing happened. Everything we learnt was linked to religion in some respect. The *Sahwah* made us think there was only one way of doing things, one voice, one system of thought. My art only began when

I understood that there were many voices. I think you can also say that my education started when I left school."

In 1992 Abdulnasser Gharem was eighteen years old. He was a tall, powerful-looking young man who was good at basketball. In a matter of months he would leave Khamis Mushait to start at the King Abdulaziz Military Academy in Riyadh. At least that was the plan.

Joining the army was a solid, respectable career choice, and a popular one following the Saudi Arabian Army's recent involvement in the Gulf War. His family was proud. His friends were impressed. But there was a delay.

The recent allied invasion of Iraq under Saddam Hussein had knocked out of kilter the country's academic and military cycles, which meant that Gharem was to enjoy an extended holiday. At some point during this hiatus he experienced what was for him an uncharacteristic period of doubt regarding the career he was about to begin. Perhaps, he felt, joining the army was not the right path.

Over the previous five years Gharem had become an accomplished artist. It began with long afternoons spent drawing life portraits – which was harder than it sounds in Khamis Mushait during the 1980s. At the time, most Saudis saw portraits as *haram*, or religiously unacceptable. Gharem's father was more accommodating, and so were the Filipino and Indian craftsmen employed at the family's furniture workshop. Gharem learnt to paint as well, and by the time he finished school he had won a number of local art prizes.

> Artist's sketches | 2008

FINE,
TELL ME
WHAT
TO PAINT

During that extended period between leaving school and joining the military, Gharem's father realised that his son was having doubts about his future. One day he took him aside.

"'Abdulnasser,' he said to me. And I was expecting him to tell me about his years in the Air Force, this kind of thing," Gharem recalls. "But he surprised me. He said, 'my advice is don't do this. Don't join the army.' 'Really?' I said. 'You should study art. Your skill is a gift from God. It is not something you can buy in the market. You must develop it.'"

Gharem took his advice and decided to study art. He went to the art department of the local university where undergraduates learnt classic methods of painting and drawing.

"I asked for a place. They told me there was an entrance exam. I said, 'Fine, tell me what to paint.' I made the paintings and showed them. They did not say anything. I came back and asked if these were okay, and I was sure they were. But they ignored me. They never said yes or no. I remember going in, pleading with them, 'please, very soon I will start at the military academy. Tell me your decision.' But they said nothing! So I became a soldier instead."

In his essay "Why I Write," George Orwell explains that one of the reasons he, or indeed anyone else, might write is to "get your own back on the grown-ups who snubbed you in childhood, etc., etc. It is humbug to pretend this is not a motive, and a strong one. Writers share this characteristic with scientists, artists, politicians, lawyers, soldiers, successful businessmen – in short, with the whole top crust of humanity."[4]

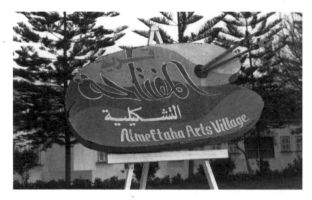

While it would be wrong to suggest that he is driven by a thinly sublimated desire to prove those university tutors wrong, all the same, this experience left a mark on the eighteen-year-old Gharem. Until then he had had little experience of rejection, and the memory of it lingered like a sore: not particularly painful but hard to forget.

Three years later, in 1995, Gharem returned to Khamis Mushait as a 2nd Lieutenant in order to serve in the nearby army base. During his military training Gharem had excelled. As he remembers it, he finished first in most of the exercises, a success that was partly due to his physique: he had always been slightly taller and stronger than his peers. But it was also down to his ability as a leader. Gharem is the oldest of eleven siblings, and in Saudi society the position of eldest son is essentially an office. With it comes considerable responsibility, and even more so for Gharem, whose father was often away on business. He regularly played the father figure to his ten siblings, doling out money for school, settling disputes and offering fatherly advice – all of which served him well at the military academy.

AL-MEFTAHA
WAS HEAVEN

Not only did Gharem excel during military training, but between the manoeuvres, the exercises, and the endless gun drills, he developed an appetite for self-improvement. By 1995 2nd Lt. Gharem was a compulsive reader. He had taught himself English and now spent hours devouring books on fine art, politics and philosophy – the very subjects he had not been taught at school. Everything he read opened up new avenues of enquiry, and now that he had a salary he was able to spend it on importing books that were unavailable in Saudi Arabia.

But what about his art? Failing to secure a place at the local university had not cauterised Gharem's desire to paint. Soon after returning to Khamis Mushait, he took a studio in the nearby Al-Meftaha Arts Village, part of the King Fahd Cultural Centre. It was a decision that would have a pivotal impact on his art.

Situated near the heart of Abha, a short drive from Khamis Mushait, Al-Meftaha Arts Village is made up of a cluster of whitewashed two-storey buildings. It feels like a haven, the atmosphere is calm and reflective. The artists come and go as they please, and there is no formal curriculum. Rather than being an art school, Al-Meftaha is a well-funded studio space that hosts frequent events.

In a European or American context Al-Meftaha might sound unremarkable, but at that time in Saudi Arabia it was unique. Here was a country that boasted the world's largest infrastructure for the production of petroleum, while its fine art infrastructure, by contrast, was miniscule. You could count on one hand the number of contemporary art galleries. There were no specialist art colleges, no art journals, independent curators, art fairs, not-for-profit artistic institutions or auctions, let alone biennials devoted to contemporary art. In every sense, there was no contemporary art scene. There was, however, Al-Meftaha, and it was a fifteen-minute drive from Gharem's front door.

"Al-Meftaha was heaven," he says. "For the first time I was around others making art who wanted to ask questions. I could show them my work and we would talk about it and criticise each other. Back then I was so happy to hear anything about my work, anything at all. For the first time, producing art involved a conversation."

During the mid-1990s Gharem continued working as a soldier in and around Khamis Mushait, building his collection of books and making art at Al-Meftaha. He had enormous reserves of energy so there was no danger of his art getting in the way of his military career. By this point the rhythm of Gharem's life was established, and it was set to continue at a steady, perhaps unremarkable pace but for one breakthrough. In the late 1990s Saudi towns and cities got their first internet connections.

"The internet changed everything at Al-Meftaha," says Gharem. "Really. It came at just the right time. I think for many Saudis in my generation the internet broke the effect of the *Sahwah*. For others it came too late. Until then we had no way of engaging with the world outside. We had only one voice to follow. With the internet, suddenly, there were many voices."

Gharem's understanding of the world was transformed. By the start of the twenty-first century his perspective became more global, "universal" as he puts it.

لا للارهاب

NO

Terrorism

"I saw myself as a citizen of the world," he says, echoing the Ancient Greek philosopher Diogenes's declaration, *"Kosmopolites eimi"* ("I am a citizen of the world"). Yet the parameters of what it meant for Gharem and other young Saudis to be citizens of the world were about to change, and they would do so dramatically.

"I remember watching the twin towers collapse on television," Gharem says. "Even after they had gone I could only think of a pause sign. That's what the shape of the twin towers looked like. It was as if the world was on hold. What happened on that day changed life in Saudi Arabia."

On 11 September 2001 two hijacked planes were steered into the World Trade Center in New York by suicidal militants. For Gharem, one of the eeriest revelations over the days that followed concerned the identity of the hijackers. Fifteen of the nineteen involved had grown up in Saudi Arabia. That was strange in itself. What really hit home was that two of them had been in the same class as Gharem at school. They were his peers, each one a product of precisely the same formal education.

"Sure, I remember those guys," he shakes his head, closing his eyes for a second. "There is no doubt that the *Sahwah* had a bad effect on my generation. Really. It's not the only reason this happened, but it had an impact."

Over the coming years Gharem and many other young Saudis were forced to recalibrate their relationship to the world. As they boarded international flights or watched certain American films they encountered a distorted reflection of themselves. They had been brought into the world, but it was not on their terms.

One of the many effects of 9-11 was a new cultural interest in Saudi Arabia and its neighbours amongst globally-minded artists, educators and academics, to name a few. Alongside military attempts to occupy physical tracts of this region came a growing desire to shift the western understanding of the Middle East and its many different people: to get beyond an archaic set of essentialist stereotypes that had developed over centuries of western engagement in the region. For many years there had been a prevailing notion that the Middle East was a discrete entity, a region governed by its own particular values that were beyond comprehension to any western mind. The Irish commentator and analyst Fred Halliday described this perspective as born of "particularism." There was a growing desire to move beyond this.

So it was with a spirit of energised cultural curiosity that Simon Reeve, working for the BBC, travelled to Jeddah in 2004. He and his cameraman planned to report on a groundbreaking exhibition of contemporary art at the Atelier Gallery, organised by five young artists from Al-Meftaha Arts Village in the south. They were Ashraf Fayadh, Muhammad Khidr, Ahmed Mater, Abdelkarim Qassim and, the eldest of the five, an army officer named Abdulnasser Gharem.

Shattah was the first in a series of exhibitions organised by Gharem and his four collaborators. The word *shattah* means "to be broken up" or "disembodied." Shattah was a bold attempt by this collective to deconstruct the traditional Saudi art exhibition. It was the culmination of five years spent in

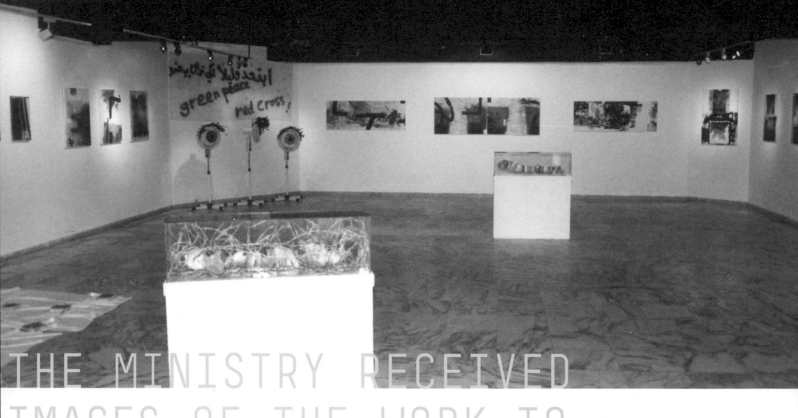

THE MINISTRY RECEIVED
IMAGES OF THE WORK TO
BE SHOWN. WHAT THEY SAW
WAS A STARK DEPARTURE
FROM THE STANDARD FARE
OF DESERT LANDSCAPES,
FALCONS, ABAYA-CLAD
WOMEN AND CROSSWORD-
PUZZLE SYMBOLISM

> Shattah exhibition, Jeddah Atelier
(all images) | 2004

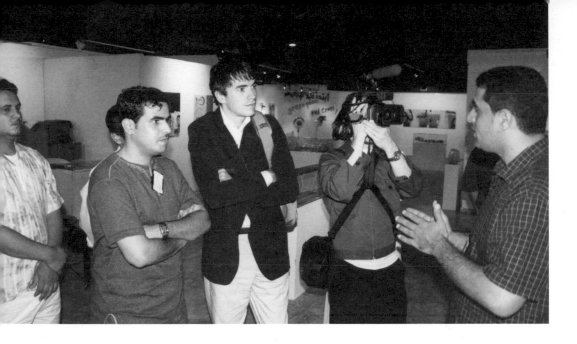

Al-Meftaha, talking, thinking, making art and learning about the world.

"Also we did a lot of dreaming in Al-Meftaha," explains Gharem. "A lot of inquiring. And at that time getting books or articles about contemporary art was so hard. Not like now. But we gathered as much as possible and shared it amongst ourselves. This exhibition was a result of the new way of seeing that came out of that, a combined way of seeing."

Establishing this new way of seeing was one thing. Sharing it with their countrymen and -women was another. Staging the kind of show they had in mind would require an equal measure of daring and delicacy.

At that time it was not possible in Jeddah, or any other large Saudi city, to simply hang a show and open it to the public. The gallerist or curator responsible had three hurdles to negotiate first.

To begin with, pictures of the work had to be sent to the relevant ministry where an initial selection was made. Once the chosen pieces had been hung, there would be a visit from members of the *Mabahith*, a religious department within the Ministry of Interior who had the authority to remove whatever they did not like the look of. A third and final inspection was carried out by a senior artist. Without any of the participating artists there to defend their work, this man—and it was always a man—would remove those works he did not want to see displayed.

"The judgements at this level were deeply personal," explains Hamza Serafi, Co-Director of Jeddah's Athr Gallery. "There were no precise guidelines as to exactly what was allowed. Sometimes the elderly artist removed a piece mainly to show that he *could*. I remember once we had a painting of a dove flying up from a bed of ash. The artist doing the last minute inspection said this was not allowed because it suggested that people in Saudi Arabia were like ash!

"But I think this process was a good discipline for the artists. It forced them to think hard about what they wanted to show. They needed to resolve their art conceptually and work through the different levels of interpretation. For me, this is what characterises Abdulnasser's work today. It needs no caption. He condenses ideas of great complexity into forms of sheer simplicity, and I think this has its roots in the way our exhibitions used to be authorised."

In the weeks leading up to the opening of Shattah in 2004, the ministry received images of the work to be shown. What they saw was a stark departure from the standard fare of desert landscapes, falcons, *abaya*-clad women and crossword-puzzle symbolism. Instead there were husks of browned chewing-gum laid out like ancient relics, miniature graves made from fast-food containers, X-ray paintings, and other works featuring spray paint, coat hangers, internet screen-grabs, Palestinian identity cards and a manipulated photograph that showed a foetus trapped in a teabag.

The way these artists worked had been influenced by the internet as well as other aspects of the digital revolution. It was now faster, easier and above all cheaper for them to produce enhanced or surreal photographs, for example. Elements of the artistic process had been democratised, and Shattah was the first exhibition in Saudi Arabia to take advantage of this.

The work also stood out in terms of how it could be read. The meanings of these pieces were open-ended. They were questions as much as answers posed in an artistic language that gloried in ambiguity.

It was perhaps this element of ambiguity that led to the ministry approving the work in Shattah. But an official backing was not enough for the company that had agreed to print the exhibition catalogue. When presented with images of the work, they refused to publish the catalogue. They wanted nothing to do with Shattah.

"They said we were crazy. So we asked someone with a connection to the owner of the printers to change this man's mind. Finally he agreed to do it."

Breaking with tradition again, for the private view of Shattah there was no formal ceremony involving a local prince, as was the norm at gallery openings. Instead, the show opened when the doors did.

More than four hundred people turned up on that first night, most of whom had received an email invitation (emailing invitations was another break with convention). To everyone's surprise, the following night more or less the same four hundred people returned to the gallery. In the days after the opening, princes' secretaries called up on behalf of their employers to ask about the meaning of certain works. The exhibition was also reported in newspapers such as Al Watan.

Shattah had caused a stir. The work had provoked debate rather than outrage and in doing so, the five artists had started to question and ultimately nudge the boundaries of what it was possible to exhibit in twenty-first-century Saudi Arabia. Yet the response to Shattah was notable for two absences. On the one hand there were no sales, so there was no danger of these artists giving up their day jobs, if they had one in the first place (Gharem was one of only two Shattah members earning a salary). The reaction to Shattah also lacked meaningful critical engagement with the work. Visitor numbers had been excellent, yes, and there had been plenty of media coverage. But the discussion had not really moved beyond the novelty of the event. It was only further afield that their work was beginning to be interpreted in the broader context of international contemporary art, and this was thanks, in part, to a visit to Al-Meftaha made the year before by the English artist Stephen Stapleton.

"It was just before the invasion of Iraq," says Stapleton. "I found myself in a remote corner of Saudi Arabia with an introduction to the son of the Governor of Aseer, Prince Bandar bin Khalid Al-Faisal. He suggested I visit Al-Meftaha. I remember him telling me, 'I want you to challenge these artists. Don't be afraid. Say anything you like to them.'"

"What I found in Al-Meftaha was thrilling. I was drawn straightaway to Abdulnasser, Ahmed Mater and the rest of the Shattah collective. I remember Abdulnasser ran a kind of *majlis* in his flat. In the evenings we all went there. He would hold court and we'd talk about everything going on, the imminent invasion of Iraq, the role of the media and the power of images. It was clear to me then, in 2003, that these artists were on the cusp of a breakthrough. While they were still making traditional watercolours in their studios, they were talking non-stop about art that was conceptually and physically more daring.

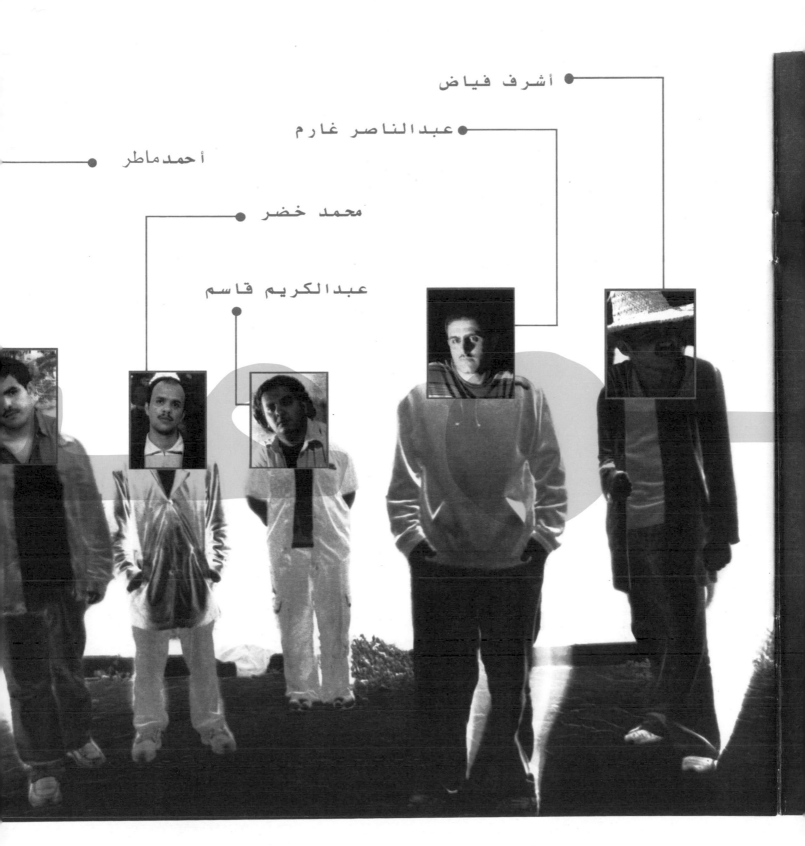

أشرف فياض

عبدالناصر غارم

أحمد ماطر

محمد خضر

عبدالكريم قاسم

The **Independent**

Read articles and features from The
Independent in Arab News every day.

Saturday, March 22, 2003
Muharram 19, 1424 A.H. • SR 2

Spot OPEC basket crude: $26.51
Prices: Gold (per 100g): SR4,114

arab news

The Middle East's Leading English Language Daily

Hell Rains Down on Iraqis

Naseer Al-Nahr
Arab News War Correspondent

BAGHDAD — The United States and
Britain unleashed a devastating air assault
on this city yesterday as their ground forces
thrust deep into Iraqi territory toward the
capital. The air attack triggered giant
fireballs, deafening explosions and huge
mushroom clouds above the city center.
US planes also hit military targets in the
northern cities of Mosul and Kirkuk with
equal ferocity.

Imams at Iraqi mosques condemned the
US-led offensive and urged the public to
fight against the US and British forces. Iraqi
Television showed Dr. Abdullatif Hameem,
imam of Baghdad's central mosque, carry-
ing an AK-47 rifle in his hand while deliver-
ing the Friday sermon, and threatening the
US forces.

Baghdad has offered attractive rewards
to every Iraqi soldier who downs an enemy
plane or missile or captures a US or British
soldier. An Iraqi who downs a fighter plane
will get a reward of 100 million dinars,
while the capture of an enemy soldier will
net 50 million dinars.

Several road accidents were reported in
Baghdad and the surrounding cities. In one
incident, a car carrying an eight-member
family overturned following an explosion,
killing the whole family who were fleeing
the bombing.

US forces fired about 320 missiles at
Baghdad and surrounding areas, a senior
US naval commander said. But Iraqi Defense
Minister Sultan Hashim Ahmed said that "no
force in the world" will conquer Iraq, at a
press conference in the middle of the mas-
sive air raid. "No force in the world will
conquer us because we are defending our
country, our principles and our religion. We
are, no doubt, the victors," Ahmed said, his
voice sporadically drowned out by violent
explosions.

Top Iraqi Cabinet ministers, one of them
brandishing an assault rifle, denounced the
United States as a "superpower of villains"
and said that US-led invaders would be
incinerated in Baghdad.

"Victory is guaranteed," Interior Minister
Mahmoud Diyab Al-Ahmed told a news
conference, defiantly waving a shiny
Kalashnikov and standing in front of a
picture of President Saddam Hussein and
the Iraqi flag. He and Information Minister
Mohammed Saeed Al-Sahaf blasted George
Bush and Tony Blair as criminals for
launching an invasion overnight.

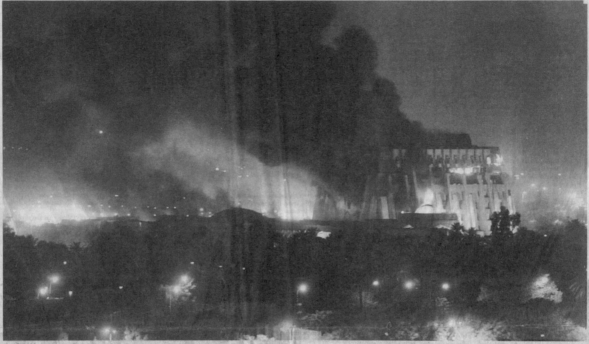

Baghdad burns on Friday night, as missiles rained on the city triggering giant fireballs and deafening explosions. (Reuters)

"They are a superpower of villains," Sahaf
said of the United States. "They are a super-
power of Al Capone," he added, referring to
the 1920s Chicago gangster. He called Bush
the "leader of the international criminal
gang of bastards".

US Defense Secretary Donald Rumsfeld
said the scale of the assault was intended
to show Iraqis that Saddam was finished
and his rule was "history". "The regime is
starting to lose control of their country,"
Rumsfeld told reporters at the Pentagon.

Iraq said Saddam had survived a US

attempt to target him directly on Thursday.
But rumors persisted that the Iraqi leader
was dead and he was not seen in public or
on television yesterday. British and US offi-
cials said they did not know whether he was
alive or dead.

Gen. Richard Myers, chairman of the US
military's Joint Chiefs of Staff, said hundreds
of targets would be hit in the next 24 hours.
He also said US and British forces would
secure oil fields in southern Iraq and were
accepting the surrender of several hundred
Iraqi troops.

He said other Iraqi soldiers were just
leaving their units and running away. Iraqi
resistance so far had been sporadic.

In a day of swift developments, US Marines
captured the Iraqi port of Umm Qasr while
other troops seized two airfields in the Iraqi
desert 140 and 180 miles (225 km and 290
km) west of the capital, part of a move to
encircle Baghdad.

British Marines launched an amphibious
and aerial assault and secured key oil instal-
lations at the head of the Gulf. Other British
troops headed for the port of Basra.

The US 3rd Infantry Division had come
under fire near Nassiriya. US troops
returned fire with rockets. US officers said
they expected soon "to go and join the
battle."

British commandos took the Faw
Peninsula on Iraq's southern tip, seizing oil
export terminals, but Iraqi troops pinned
down US Marines pushing toward the port
of Umm Qasr for two hours before British
artillery blasted the Iraqi defenses open.

US and British forces seized two boats off
southern Iraq carrying 68 mines, military

officials said. In the first day of fighting, two
US Marines were confirmed killed in action.
Eight British and four US soldiers died in a
helicopter crash in Kuwait. It is not known
how many Iraqi soldiers are dead.

Meanwhile, Turkey yesterday opened its
airspace to US warplanes bound for Iraq
after 24 hours of tense gamesmanship.

"It has been determined that it is in
Turkey's interests to open Turkish air-
space," Defense Minister Vecdi Gonul told
reporters.

— *With input from Agencies*

'War Waged in a Surreal Landscape'

Barbara Ferguson
Arab News War Correspondent

AN AIR BASE IN KUWAIT — The war
to "liberate" Iraq has taken on a surreal
dimension here.

Since Thursday morning, when President
George W. Bush told the world that US
Tomahawks had been launched and that
war had begun, journalists and US Marines
in Kuwait have spent a good part of each
day — and night — in bunkers, as Iraq
launched Scud missiles at them.

Information about the military campaign
has been scanty, at best. The "embeds" have
been kept almost totally out of the loop
when it comes to details, strategies, direc-
tions, movements or even the commanding
general's general game plan.

As a result, Marines get a kick out of
teasing embeds so desperate for news that
they gather at the few televisions in this
compound.

"Hey, embed, I thought you were sup-
posed to be telling the news, not watching
it," a Marine lobbed at one point.

In addition, there is resentment at the sig-
nificant news leaks that some of the TV talk-
ing heads are making during newscasts.

One former Marine officer — now a TV/
radio star — who should know better than
anyone the importance of not compromising
the safety of troops yesterday broadcast to
the world a US pilot's last name, which is
strictly forbidden, and his squadron num-
ber, which is also top secret.

Most embeds here are without powerful
friends in the right places to protect them,

and word is that some 60 of them have
already been thrown out of the program for
co-opting the troops by revealing too much
information.

There is also news that up north, embeds
are dropping out of the program like flies,
unable to hack the tough life the Marines are
currently living in the desert.

All people on this base have spent the last
36 hours in a MOPP suit which is a heavy
charcoal lined suit designed to repel any
NBC (Nuclear, Biological or Chemical)
contamination. The heavy suit is encumber-
ing and very hot and uncomfortable in the
desert heat.

If a siren sounds, one is trained to "don
and clear" their gas masks in nine seconds
— an action that effectively seals the face
and lungs from contamination, but which

also causes the eyes to water and the throat
to swell.

The troops here must also wear oversized
rubber boots, again to avoid the risk of pos-
sible contamination, and wear flak vests,
steel helmets and canteens.

Incoming Scuds are greeted with a fren-
zied gasp of delirium as Marines struggle
to seal their MOPP gear whilst also hastily
hobbling over to the nearest bunker.

The bunkers, reinforced cement struc-
tures the shape of an inverted "U" are
rapidly filled with panting, tightly packed,
sweating bodies, all seeking protection from
a possible incoming missile. The waiting is
awful. No one speaks and quiet thoughts
range from spiritual through treasured to
mundane, anything that distracts from the
fear of what may be incoming.

Scuds Fall Into Watery Grave off Kuwait

Abdul Rahman Almotawa
Arab News War Correspondent

KUWAIT CITY — A vehicle carrying a
team of Arab News journalists was shaken
at about 8.30 p.m. yesterday as a surface-

to-surface Scud missile launched by Iraq
on Kuwait passed by the vehicle and fell into
the sea.

It was the second Iraqi missile to end up
in the sea. Anticipating this, Kuwaiti authori-
ties said they did not set off the sirens.

Meanwhile, black clouds appeared north
of Kuwait amid reports of 30 burning oil
wells. American military sources told Arab
News that the cause of the oil fires was still
unknown. In their Friday sermons, imams
at mosques in various parts of Kuwait urged
the public to stand united and safeguard the
country's security and stability.

First Lt. A. Al-Khorafi Mosque read out
a statement from the Ministry of Endowment
urging the public to refrain from activi-

Normalcy returned to Kuwait yester-
day as many people enjoyed their food at
public restaurants and recreation centers.
However, restaurant owners said that there
was a noticeable fall in the number of
customers. Many had traveled abroad as
repeated sirens sounded 12 times in the city
in the last two days. The Education Ministry
declared a seven-day official holiday for the
state, beginning today.

First Lt. A. Al-Rushaidi, an officer at
Salimiya police station, disclosed that his
office had not arrested any troublemakers
or saboteurs over the past two days. "Things
are stable in the area as well as in Kuwait,"
he added.

A group of Kuwaiti youth gathered yes-

restaurants and coffee shops told Arab News
that they were sure the US-led alliance
would emerge victorious.

Remnants of a Scud missile fell in Jahra
Al-Ahmadi on Thursday and a Kuwaiti mili-
tary source told Arab News that nobody was
hurt.

However, the debris destroyed the glass
fronts of a number of shops in the area.

Meanwhile, security has been beefed up
at the Hilton Hotel in Ahmadi, the media
headquarters of the American forces.

Kuwait's streets, normally busy with peo-
ple cruising on the weekend, were filled with
checkpoints where drivers were stopped to
show their identification papers.

They grew more deserted as the day wore

Vol. XXVIII • No. 115 • 24 Pages

http://www.arabnews.com

arabnews@arabnews.com

Pricing: Bahrain 200 F • Egypt 3 P
Iran 200 R • India 12 R • Indonesia 2,000
R • Japan 250Y • Jordan 250 Fils • Kuwait
200 Fils • Lebanon 1,000 L • Morocco 2 D
Oman 200 P • Pakistan 15 R • Philippines

ABDULNASSER RAN A
KIND OF MAJLIS IN HIS
FLAT. IN THE EVENINGS
WE ALL WENT THERE.
HE WOULD HOLD COURT
AND WE'D TALK ABOUT
EVERYTHING GOING ON,
THE IMMINENT INVASION
OF IRAQ, THE ROLE
OF THE MEDIA AND
THE POWER OF IMAGES.
IT WAS CLEAR TO ME
THEN, IN 2003, THAT
THESE ARTISTS WERE
ON THE CUSP OF A
BREAKTHROUGH

> Arab News | March 2003

SLOWLY, WORD
SPREAD ABOUT THIS
UNUSUAL GROUP OF
SAUDI ARTISTS

"There was a real hunger there, and a curiosity. I think they challenged me as much as I challenged them, and this was the starting point for a really strong and collaborative relationship."

With the invasion of Iraq underway Stapleton returned to London, and over the ensuing years he remained in close contact with the Shattah group. He began to show pictures of new work they were making—which continued to be conceptually more daring—to fellow artists, collectors and curators back in London. Slowly, word spread about this unusual group of Saudi artists.

At one point after Stapleton's visit, Gharem sent him a photograph of an installation he had made shortly after the invasion of Iraq in 2003. It was called *Siraat* , and it took Stapleton by surprise.

> Al-Meftaha Arts Village, Abha

> Shattah exhibition, Jeddah Atelier | 2004

> The artist with Stephen Stapleton,
Ahmed Mater and Wael Gharem | 2003

SIRAAT

It had rained for days around
Khamis Mushait. Nobody could
remember it raining this hard.
Gharem was nine years old. He went
with his family to the hills
beyond their home to watch the
swollen river as it inked through
the landscape. In the distance
he could see villages that looked
safe and secure lodged in the
valley clefts. It was not until
much later that he found
out what had happened in one
of these villages...

الله الله الله الله الله الله الله الله الله

الصراط المستقيم بين العبد و المعبود

العبد

AL SIRAAT

> Artist's sketch for Siraat (The Path)

The village had grown up around the road that runs south from Khamis Mushait towards Yemen. The landscape is jagged and dry, with spidery paths that run out over the valley walls. High above birds of prey zig-zag hard against the sky.

The villagers had heard about the heavy rain to the north, and given the risk of flash floods, they had decided to take shelter on higher ground. As Gharem and his family gazed down on the upper reaches of the same valley, the men in this village discussed exactly where to take their families.

Only a few years earlier the road that ran past the village had been upgraded. Now it included state-of-the-art tunnels, embankments and concrete bridges including one that had been built several hundred yards from the edge of the village. The bridge was a sturdy-looking thing supported by concrete pillars that had been lined up in threes. The villagers gathered their possessions and livestock and took them to the bridge where they settled down to wait for the flood.

When the water came it was strong and wild, straining at the concrete pillars. It heaved up, over and around them until the cracks became fissures and with a terrible judder the supports gave way. The bridge collapsed. It and the villagers were washed downstream. Most of them died.

Newspapers in Saudi Arabia are often reluctant to give their readers bad news, so this tragedy went unreported. At the time, it did not belong to an official version of history.

Of course everyone in Khamis Mushait knew about what had happened, and in the months and years that followed they would be reminded of it every time

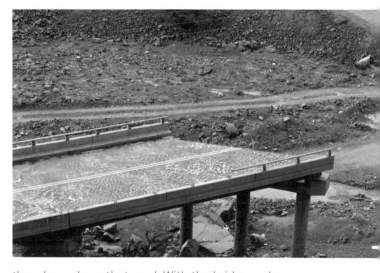

they drove down that road. With the bridge no longer in place, the road took a detour past the remains of this structure. Seen from below it was a savage sight. You could see where the central concrete sections had been ripped out and what remained jabbed awkwardly out into the valley.

Gharem had driven past this site many times. He knew the story of what had happened inside out, but he had always felt that this tale was open-ended. Where was the affirmative moral, the conclusion?

For some people the lesson of the story concerned those behind its construction. Legend has it that the road was built by the Bin Laden Construction Company, and that when the work was finished a senior figure within the corporation had declared, "the bridges we have built will last for a hundred years."

He forgot to say, *Mashallah* (it is God's will). For many Muslims if you make a grand claim you should add

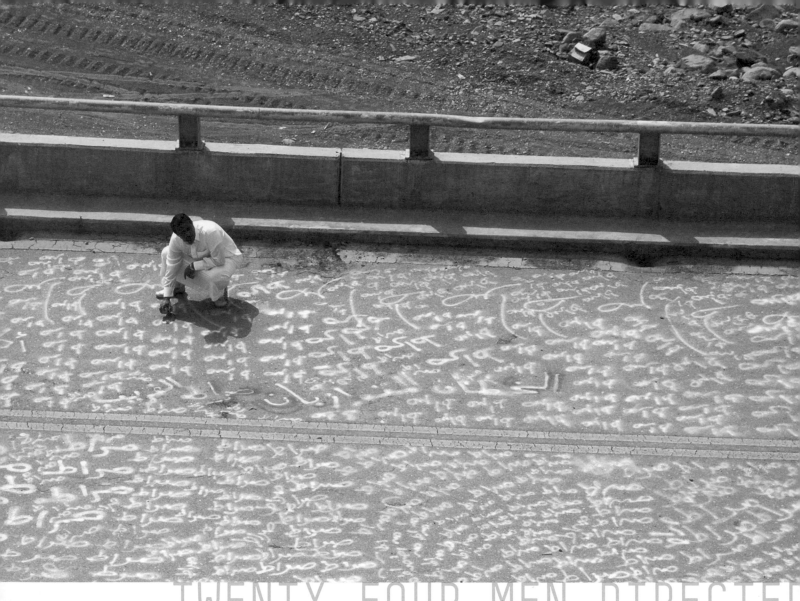

TWENTY-FOUR MEN DIRECTED
BY GHAREM SPENT FOUR
DAYS AND THREE NIGHTS
SPRAYING A SINGLE
WORD ONTO THE ROAD:
SIRAAT

> Performance of *Siraat (The Path)* | 2003

the word *Mashallah*. If you fail to do this God may remind you of His power, and that when extraordinary things happen it is His will. In this particular reading of the story the destruction of the bridge was a punishment from God. Gharem had an alternative moral in mind.

On a bright day in 2003 Gharem loaded up his car with cans of white spray paint, food, coffee and tea and gathered up several brothers and a handful of close friends. Together they drove to the collapsed bridge where they began to spray-paint a single word repeatedly onto the cracked surface of the concrete.

"After six hours of this we realised it would take so much longer than I had thought," says Gharem. "So I called more people. But I had to be careful. There were some who would not do it. They thought it was not right."

In total, twenty-four men directed by Gharem spent four days and three nights spray-painting until the remains of the bridge were covered with this single word written out thousands of times. The word was *siraat*. It means "the path" or "the way." In one sense, *siraat* refers to the choices that you make in life and whether you follow the right path. *Siraat* also has a religious implication. In the Qur'an it is used in reference to the Day of Judgement and the bridge over hell that leads to paradise. For sinners this path is as thin as a hair but sharp as a sword. For those who have followed the right path the bridge is broad and straight.

By the time the last of the *siraats* had been sprayed Gharem had not slept for days. You can see something here of his steely will - once he is committed to a project he will keep at it until it is finished. Curator

and collector Basma Al-Sulaiman explains, "there is extraordinary determination and discipline in his work. I think it comes partly from his military background. If it had taken a month to produce *Siraat* he would have kept going until it was done."

Once completed, Gharem stood before the bridge with its foaming delta of text that rushed on towards the edge of the concrete. He decided to make a film then and there, only he was not sure what form it should take. As he deliberated with his platoon of assistants, Gharem spotted a herd of goats jangling across the slope above. If they could only get them down to the bridge...

The goats resisted all entreaties to join this band of spray-painters. They would only respond to their goatherd: a slip of a boy in a sarong and kamise with flowers in his hair, one of the Flower Men of southern Saudi Arabia.

"So I called him down," says Gharem. "We gave him food and I explained about the piece. He liked it. He said we could use his goats. So we filmed it with these goats. It was perfect. You see these goats put

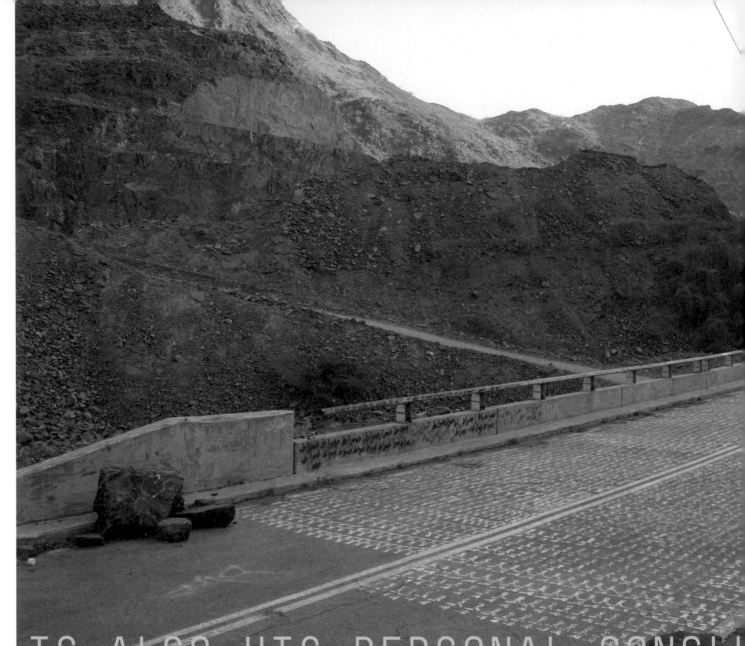

IT IS ALSO HIS PERSONAL CONCLU

THIS TRAGEDY: A WAY OF MEMORIA

A SPECIFIC MOMENT WITHIN AN

UNWRITTEN HISTORY

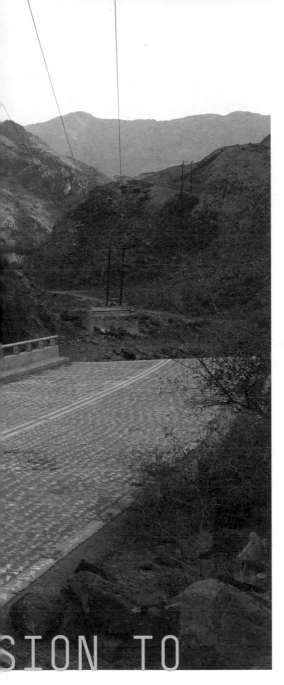

SION TO
LISING

their faith and trust in the goatherd only. They do not question. They follow."

The video of *Siraat* was shot at night using the camera's night vision. Cars pass by like shooting stars in slow motion. None of the drivers can see what has been spray-painted onto the remains of the bridge, so there is something clandestine about this piece. You can see it only if you know where to look. The ghoulish, washed-out imagery in the video is accompanied by the Sufi singer Dafer Youssef, whose voice imbues the piece with a crushing melancholy. It floods the work as you watch the green-lit goats meander over the concrete stump and its sea of *siraats*. Here is a video that aspires to maximal catharsis.

While it is tempting to position this work within the context of land art and other landscape-based interventions, really it belongs elsewhere. If nothing else, at the time Gharem did not think of *Siraat* as an intervention or performance. For him, it was simply a physical response to a story that had had a huge effect on him and in some ways shaped him. It is also his personal conclusion to this tragedy: a way of memorialising a specific moment within an unwritten and unofficial Saudi history.

In this sense, Gharem becomes the *rawi*, or poet, of an imaginary tribe made up of those without a voice of their own. In a more formal manner Gharem challenges and ultimately alters the function of this man-made wreck. He lays claim to an object that is otherwise *terra nullius* (as the Ancient Romans described land without an owner). This is where we begin to see Gharem not only as the virtual *rawi*, but the archetypal trickster-figure.

> *Siraat (The Path)* video on display in Venice | 2009

> *Siraat (The Path)* video on display in Istanbul | 2010

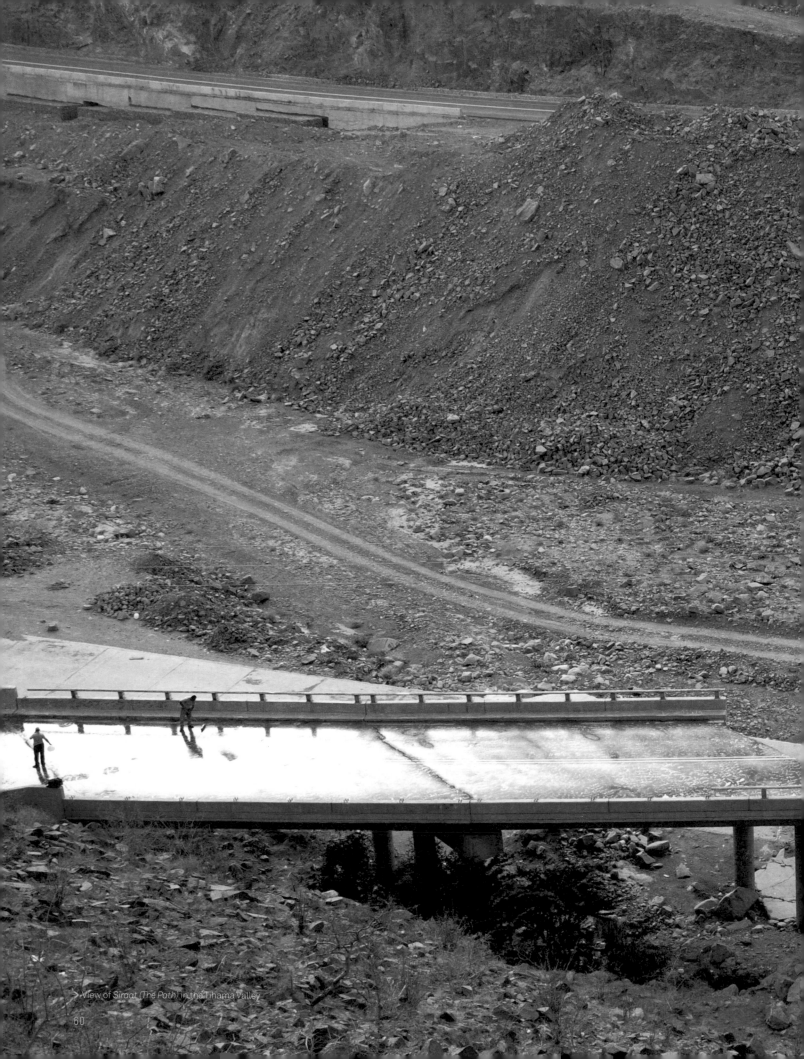

> View of *Siraat* (*The Path*) in the Tihama Valley

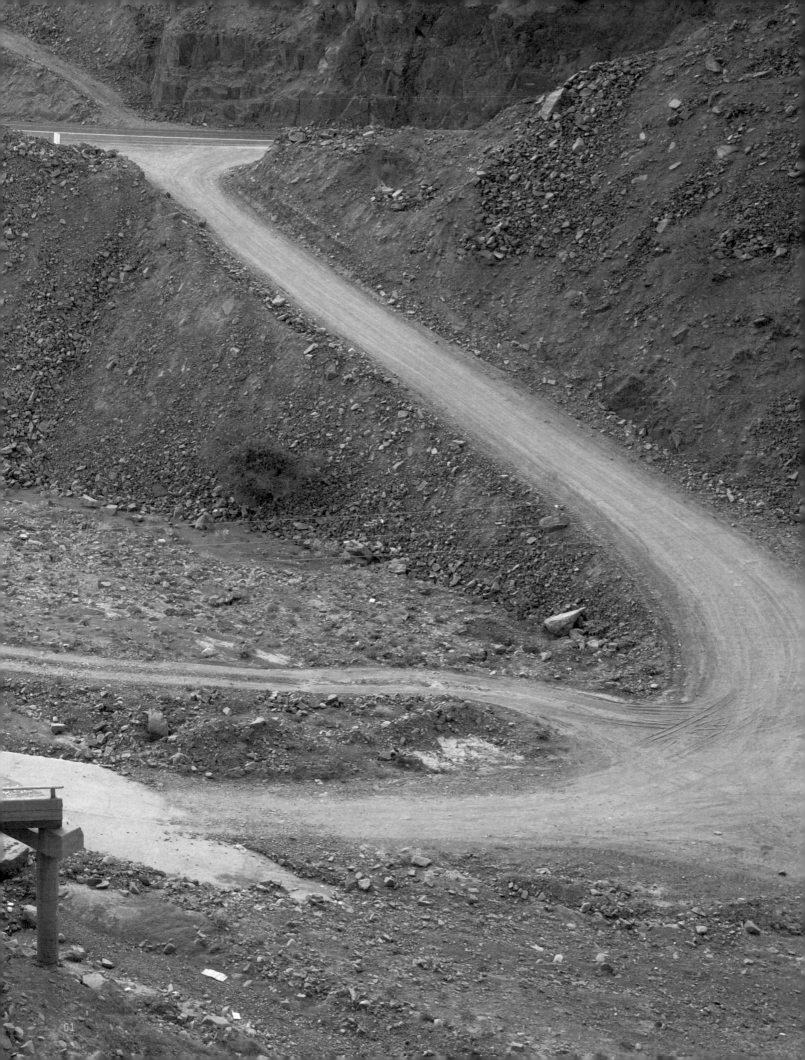

"All tricksters are 'on the road'. They are the lords of in-between," writes cultural critic Lewis Hyde. "He is the spirit of the road at dusk, the one that runs from one town to another and belongs to neither."[5] The road stands for territory that belongs to nobody, for setting out into the unknown. This is where Gharem thrives. He is forever on the road, literally and conceptually. To clear his head he will go for a drive, and in a similar sense, the yellow lines that run down the centre of Saudi roads appear throughout much of his work.

Though he could have had no idea at the time, what happened in 2003 in that remote valley was merely the first chapter of the *Siraat* saga. Photographs of the piece would later be banned from exhibitions. They would become internationally recognised examples of unofficial censorship. They would also be praised by senior figures within the Saudi cultural establishment and acquired for prestigious collections ranging from The Los Angeles Museum of Contemporary Art to a joint collection run by the British Museum and the Victoria and Albert Museum in London. But for many years *Siraat* remained something of a secret that was known only to Gharem, his helpers, a handful of fellow-artists and a goatherd.

> Detail from *Siraat (The Path)*

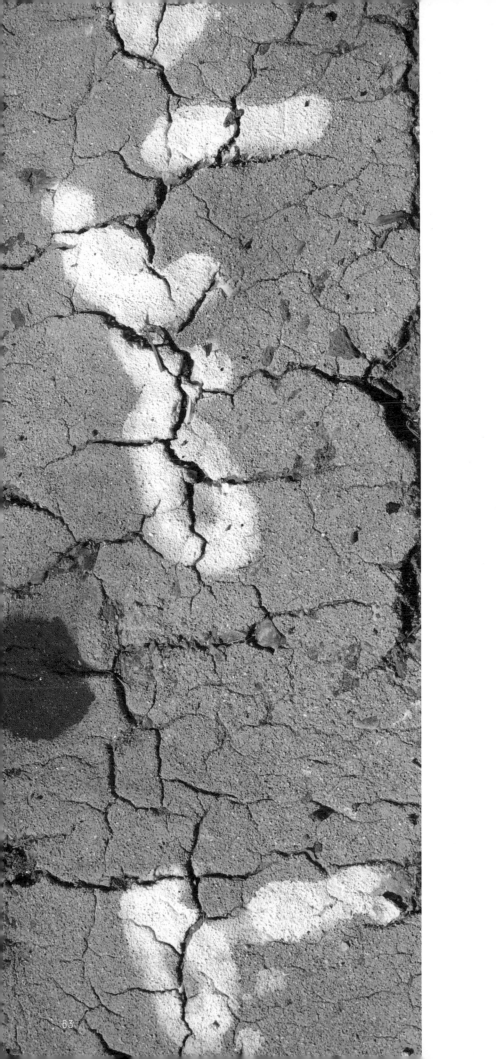

PLATES

PLATES 1

SIRAAT (THE PATH)
MESSAGE/MESSENGER

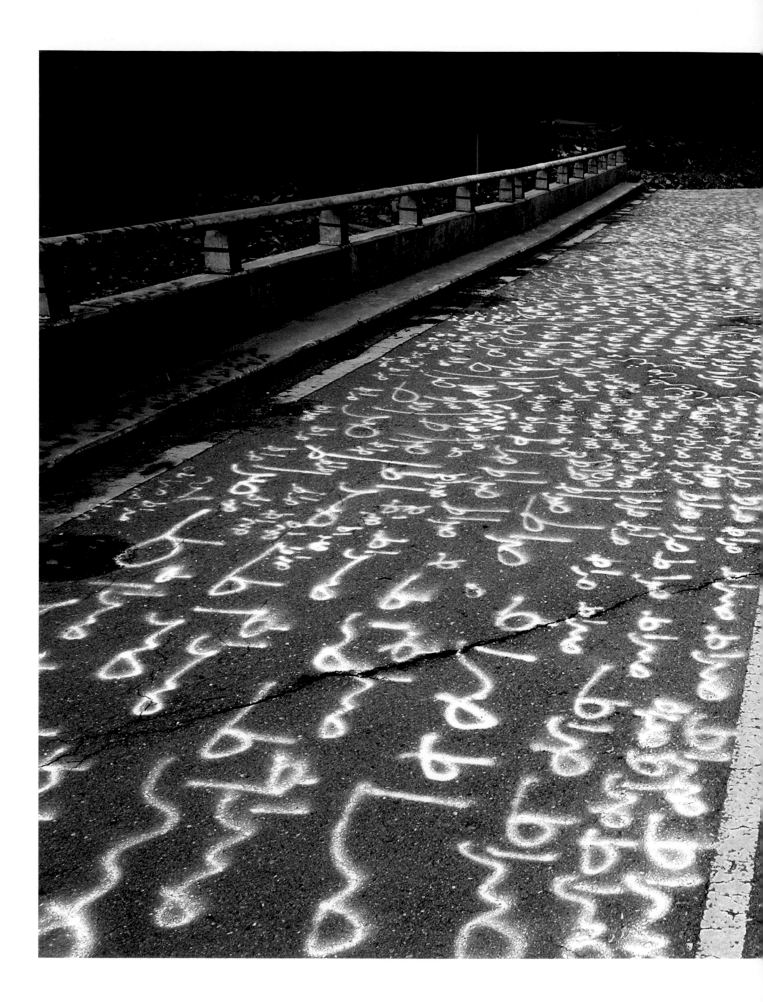

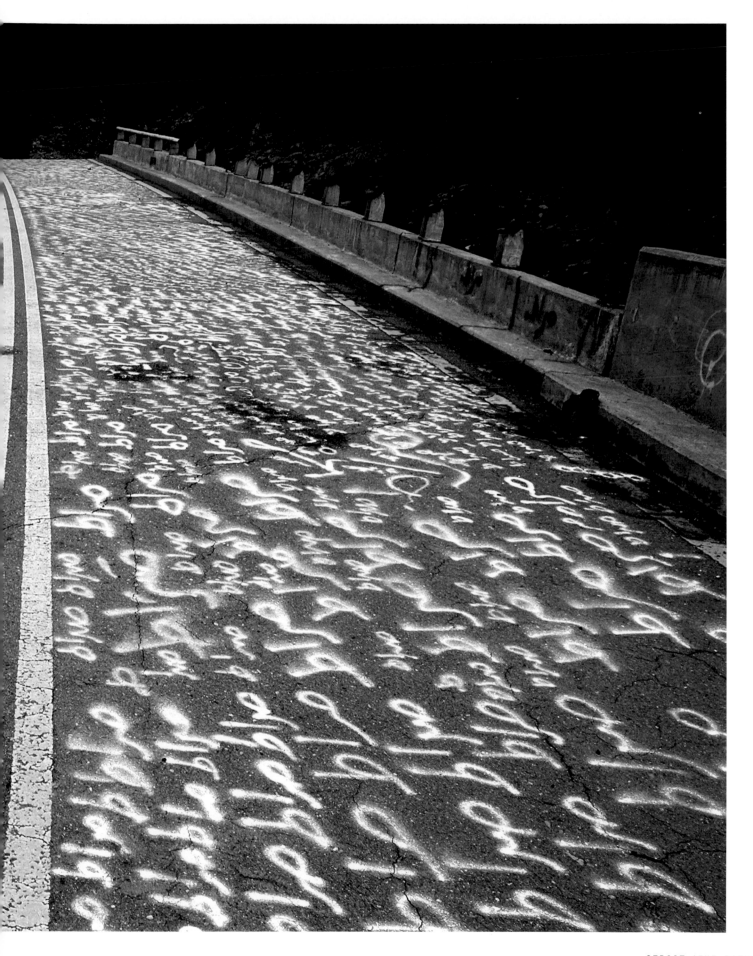

SIRAAT [THE PATH]
PHOTOGRAPHIC / SILKSCREEN PRINT
2007

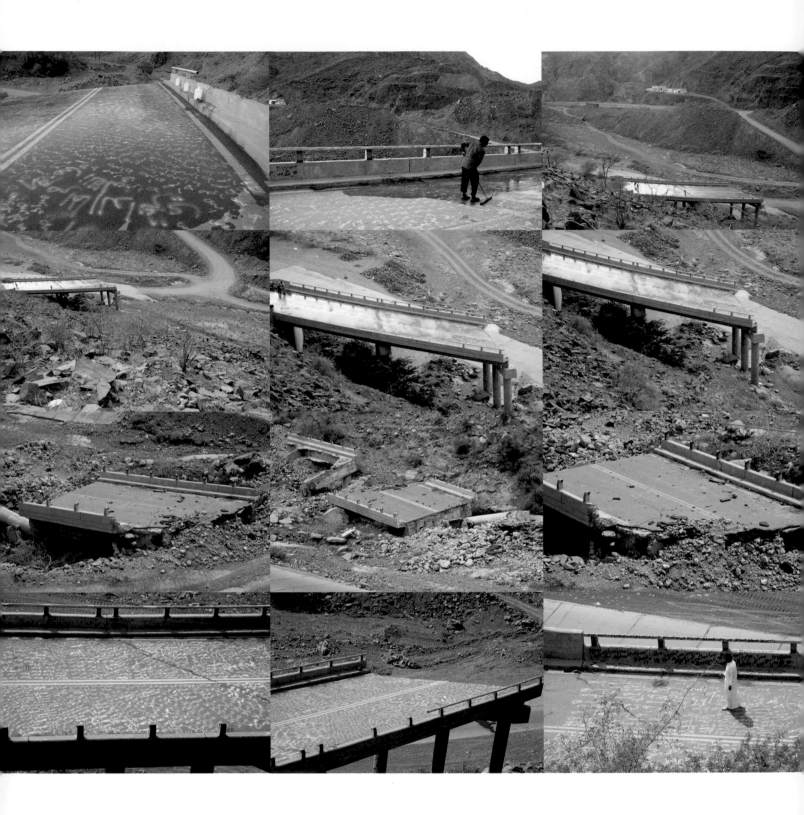

> Views of *Siraat (The Path)* in the Tihama Valley

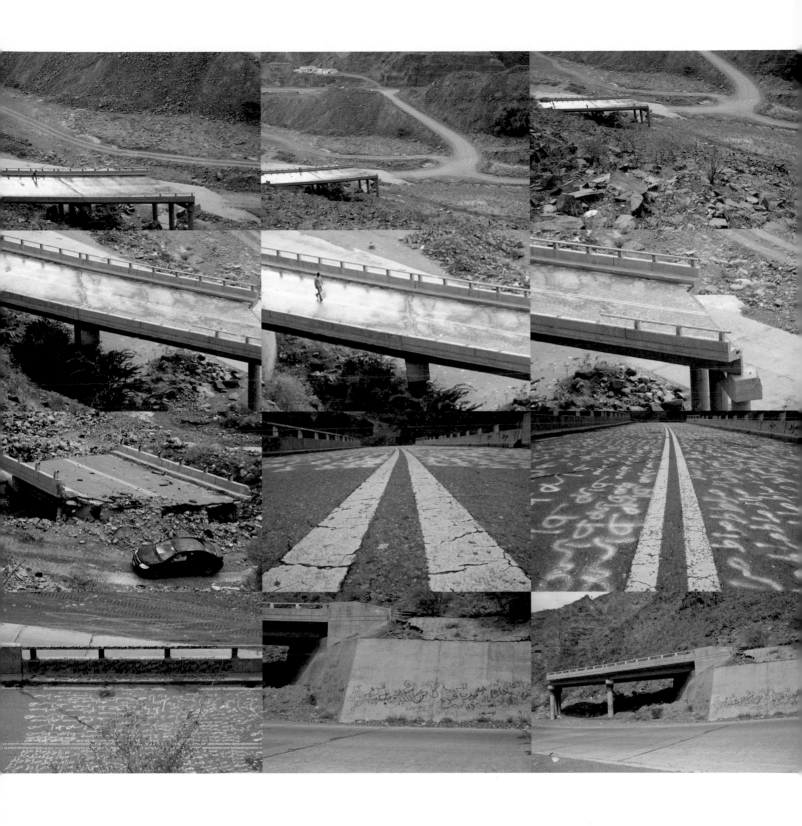

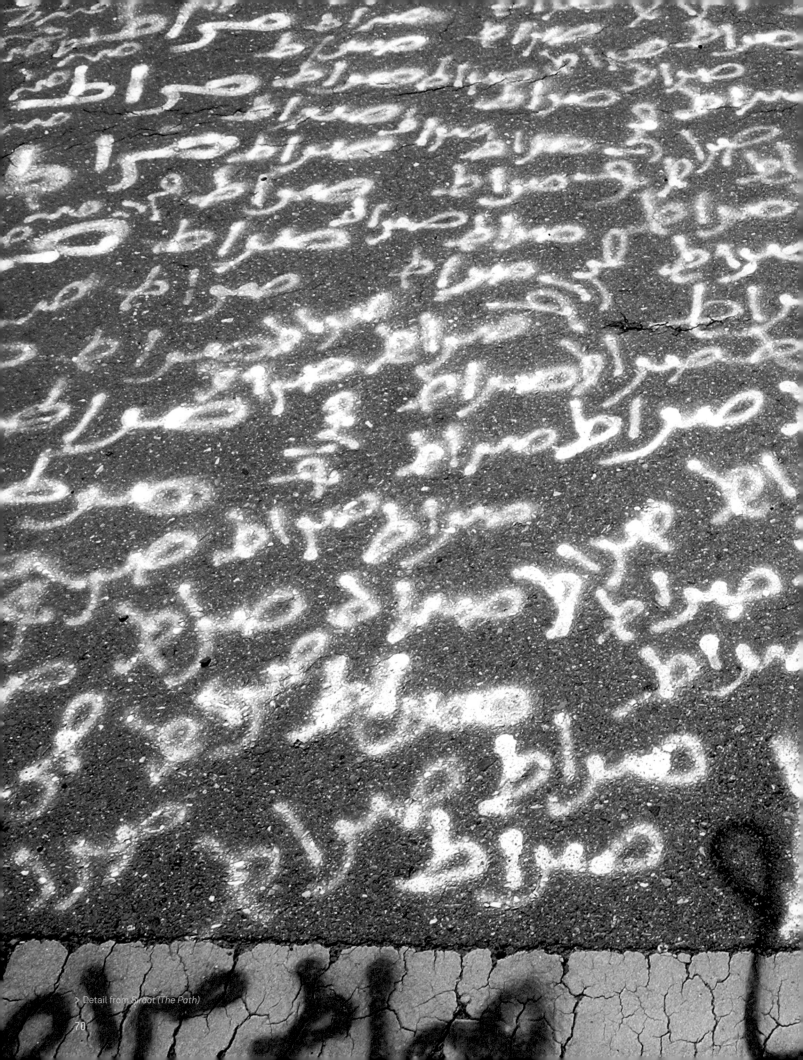

> Detail from *Siraat (The Path)*

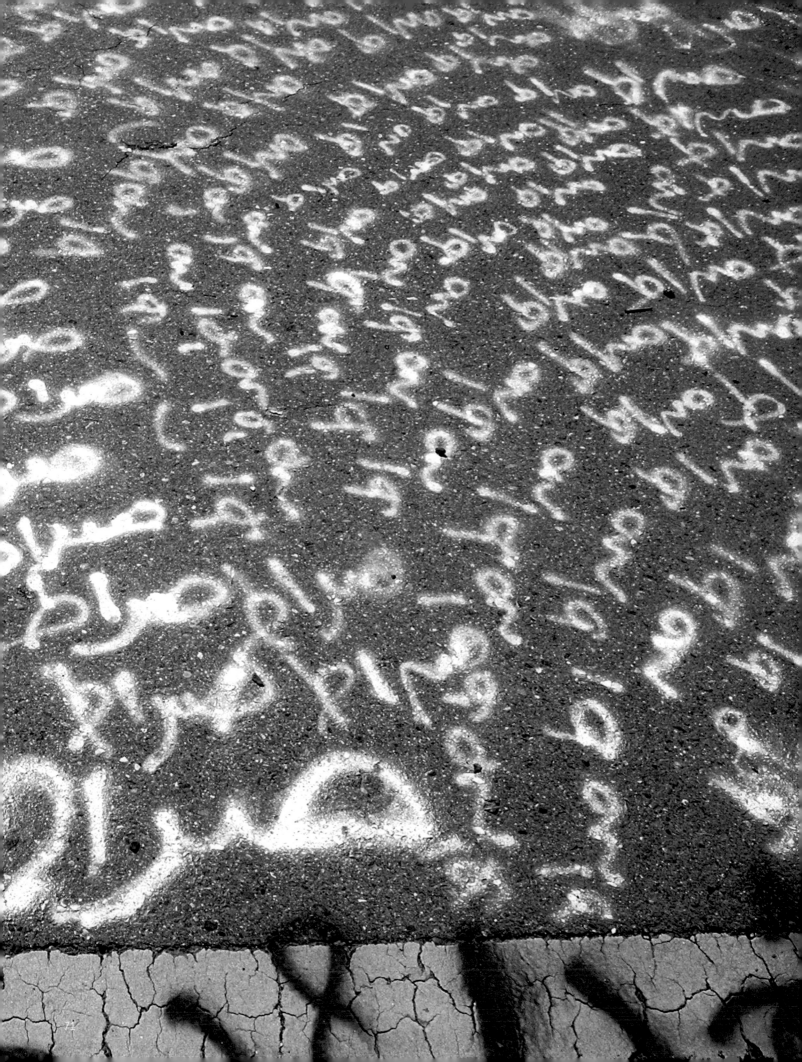

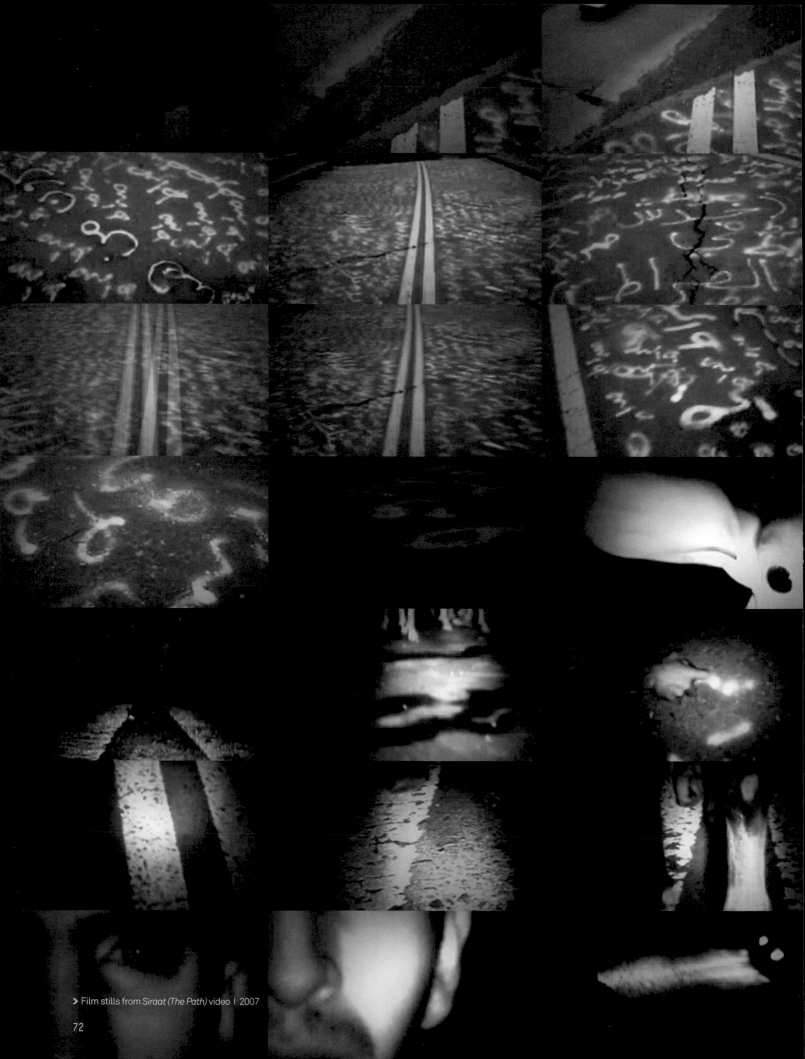

> Film stills from *Siraat (The Path)* video | 2007

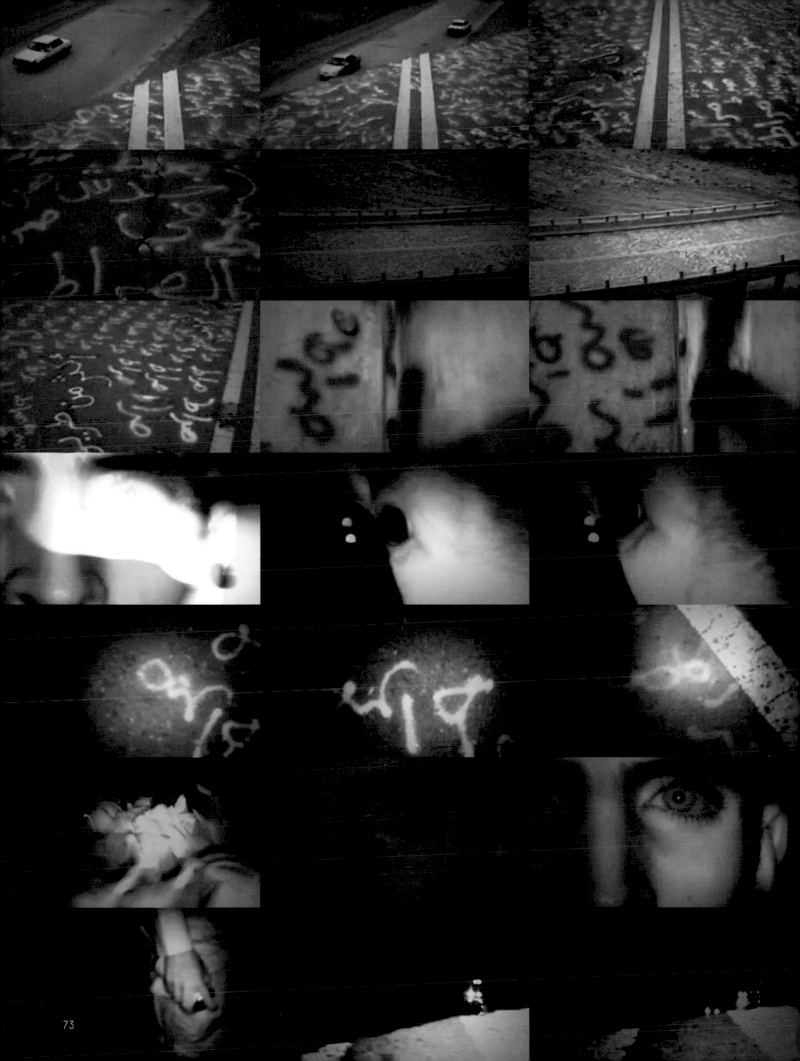

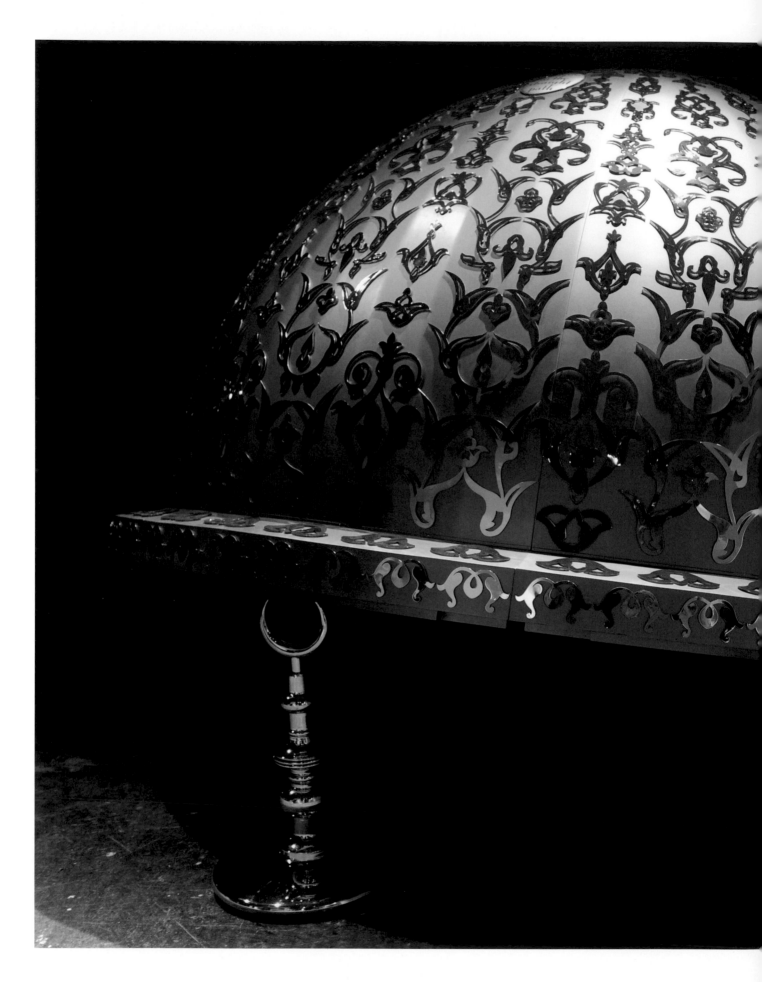

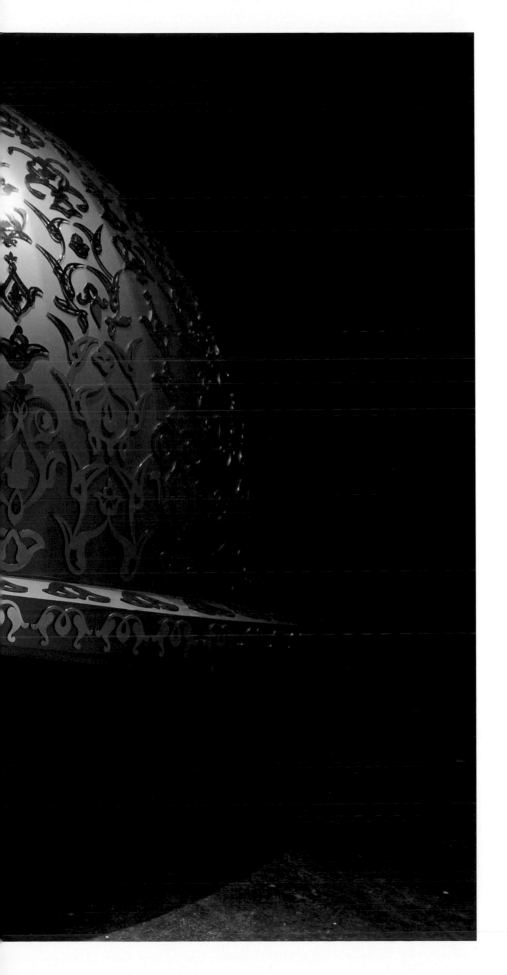

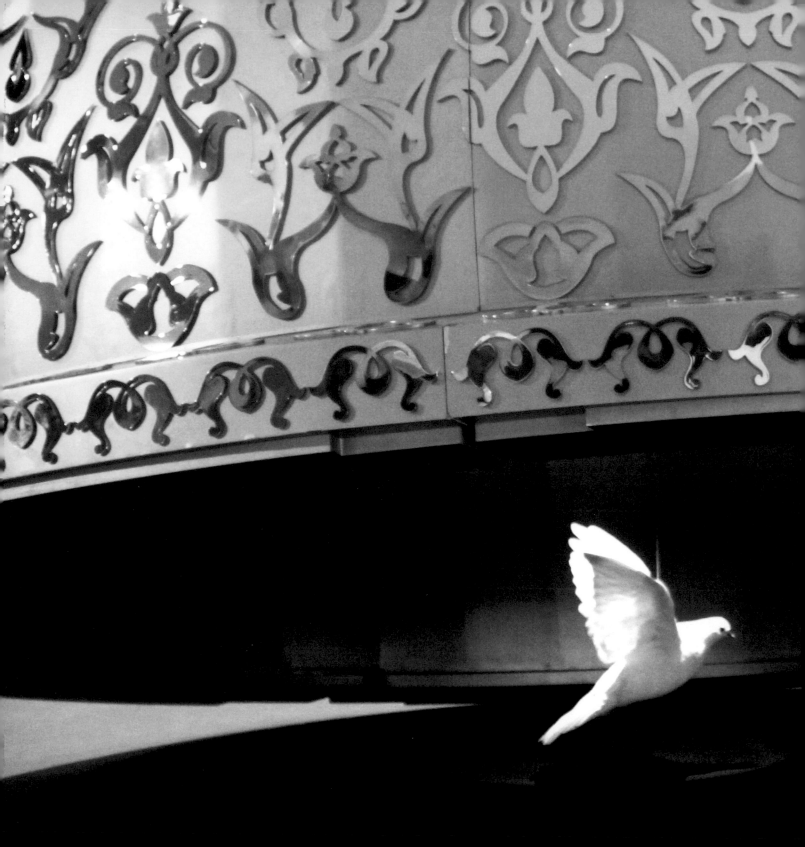

> Detail from *Message/Messenger*

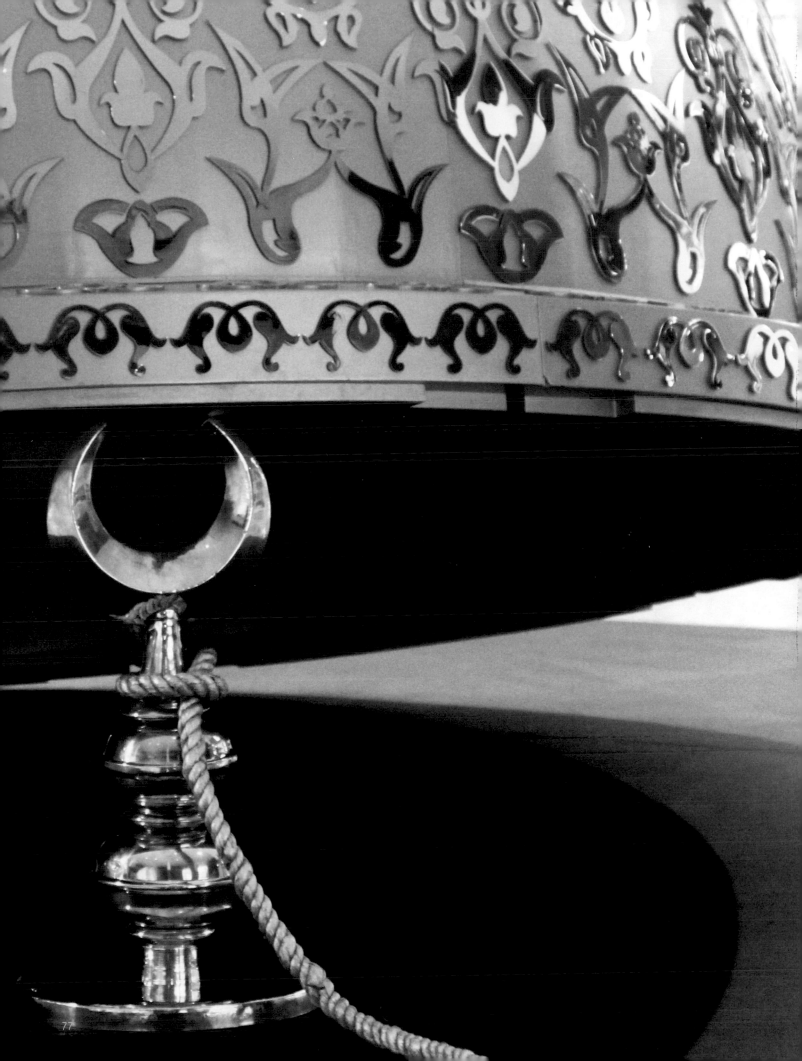

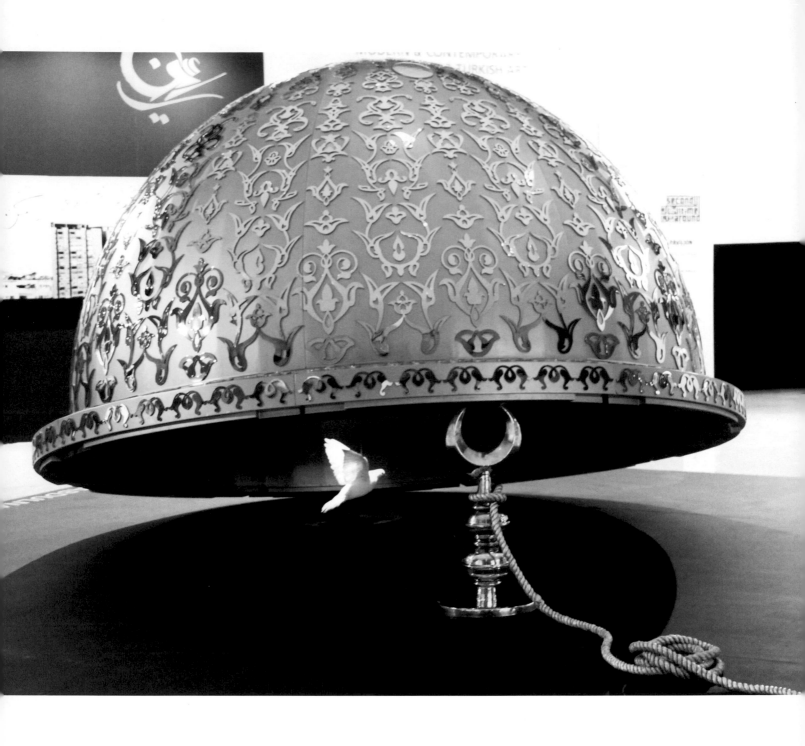

FLORA & FAUNA

Karam Sahadad Ali is a giant of a man with a thin moustache and hands like paddles. He grew up in Mumbai and arrived in Khamis Mushait just after the first Gulf War. There he found work as an upholsterer in the prestigious Bin Ajlan furniture company...

> A *Conocarpus Erectus* tree in Khamis
Mushait (this page) and being planted in
the Gulf (opposite page)

Over the years Ali got to know the general manager's eldest son, Abdulnasser, who one day in 2006 asked Ali if he'd like to accompany him on an unusual expedition. Their first task was to find a particular type of tree.

Back in the 1980s the municipal authority for Abha and Khamis Mushait learnt about a drought-resistant tree called the *conocarpus erectus*. It came from Australia and had a lovely, bushy crown. Better still, it seemed to need very little water.

Abha and Khamis Mushait were popular domestic holiday destinations. The chief selling-point for this part of the country was climatic. There was more rain here than anywhere else in the country and in theory, the introduction of the *conocarpus erectus* would only add to the lush, well-watered feel of the place.

Soon after Gharem had moved to Khamis Mushait the municipal authority had thousands of *conocarpus erectus* saplings planted down the main streets. They flourished, and, as promised, their leaves remained a vibrant shade of green all year round. But as the *conocarpus erectus* reached maturity a strange thing happened. Nearby cottonwoods, willows and other indigenous trees started to die off. Nobody knew why. The afflicted trees were not too old and there was no evidence of disease.

It turned out that these trees were dying of drought. Most had compact root balls that sought moisture deep in the ground. The *conocarpus erectus* has a different strategy. Its roots shoot out in horizontal veins that keep close to the surface, drinking up water before it can reach the roots below. In short, the balance of the local ecosystem in Abha and Khamis Mushait had been upset by the introduction of

these imported trees. Abdulnasser Gharem planned to stage a performance that would highlight what had happened.

He began by looking for a suitable tree with Ali. After one false start they agreed on a *conocarpus erectus* towards one side of a busy commercial street in the heart of Khamis Mushait. The shopkeepers were agog as Ali and Gharem proceeded to cover the tree with a broad and transparent sheet of plastic. Having secured the corners to the base, Gharem stepped inside this plastic cocoon in his pristine white *thobe* and *shemagh*, while Ali began to take photographs.

It was an extraordinary sight. For the critic Ana Finel Honigman, the addition of plastic made "the full-grown greenery look as inconsequential and uninviting

as a grocery store's shrink-wrapped broccoli." It offers, she goes on, "an eerily apocalyptic vision of a world where trees are so precious and odd that they are preserved like artefacts, barred from attaining the natural existence they crave."[6]

In Khamis Mushait the performance was met with curiosity and perplexity. A crowd gathered around Gharem and Ali. Cars slowed to a crawl. A traffic jam ensued. There was honking, questioning and all-round confusion. Nobody knew what to make of it.

"Some people thought I was crazy," says Gharem. "But they wanted to know more. Their minds are not closed, so they came over to ask about it. When they understood it, they liked it."

Gharem survived in his cocoon thanks to the oxygen produced by the tree. After an hour in the midday heat he was also able to survive thanks to the small hole that had been burnt in the plastic by the sun.

Ali was surprised by the different reactions. There was far more curiosity than he had expected, a more pressing desire to learn among the people who witnessed the event. The other thing that surprised him was how many young boys wanted to step inside the cocoon. The final reaction to this performance was less hospitable. Members of the municipal authority heard about Gharem's intervention and when they saw what he was up to, became convinced that Gharem and Ali were trying to kill the tree. The performance was soon stopped.

"Our architects and planners need to consider the environment more carefully in their designs," Gharem later wrote. "Our technology needs to accelerate in

this sense. We need a philosophical analysis of the relationship between the technological and the natural."

Gharem called this performance and photographs of the event *Flora & Fauna*. With it, he positioned himself for a moment in real and symbolic equilibrium with nature, so that neither he nor the tree suffered. In other ways *Flora & Fauna* was about received wisdom and when to question it. Some of the passersby who saw Gharem wrapped in plastic thought he would not be able to breathe. They had not accounted for the oxygen produced by the tree.

"It is like the story of the ostrich with its head in the sand," he says. "When you are a child this is used as an allegory for someone who is old-fashioned and afraid of change. That's what I learnt when I was young. But later I found out why the ostrich puts his head in the sand. It's to hear what's coming in the distance. The ostrich is not stupid. It has an impressive understanding of sound transmission. When I heard this I had to revise the story I was told as a child."

It was 2006 and Gharem was starting to find his artistic voice. He had begun to question his surroundings, as well as what he had been taught, and did not mind being laughed at occasionally. Out of *Flora & Fauna* came further performances exploring our ongoing relationship with the physical environment and the intersection between this and our everyday, unthinking habits.

One such performance in 2006 was *Dung Beetle*, for which Gharem constructed a large wooden cube and covered each side with transparent plastic. Next he filled it with car exhaust until the sides turned tar black. Having sealed up the hole he spent the

afternoon rolling this blackened cube through the streets of Khamis Mushait. After an hour he reached the Old Market.

"There, everybody asked me what was inside. When I told them they did not believe me. They thought car exhaust was clear, that it did not pollute like this. I wanted to show them that this is what happens when we get on the road. Everywhere I went, people were talking about it. There was a reaction."

Soon after this performance he heard that *Flora & Fauna* had been accepted for the 8th Sharjah Biennial, to be held in 2007. In that year only two Saudi artists were invited to take part in this prestigious international exhibition: Abdulnasser Gharem and Ahmed Mater, both of whom had been part of the Shattah collective.

This was a major breakthrough. Until then the participation of Saudi artists in international exhibitions was generally controlled by the Ministry of Culture and Information. They sought the advice of older artists who decided who to put forward. It was a conventional system based on seniority and sinecure. Without really meaning to, Gharem and Mater had slipped past all that. At last they were beginning to experience the kind of recognition and critical engagement they had dreamt of in the wake of that first Shattah exhibition. The only downside was that it was not happening in Saudi Arabia. For that kind of recognition and engagement they would have to wait.

MANZOA

On the outskirts of Jizan lies an
empty strip of land. It is strewn
with rubble and the blistered remains
of door-jambs. Once there were homes
here. Fishermen had built a cluster
of box-like dwellings yet they had
done so without permission from the
local authority. The fishermen and
their families were told that their
homes were illegal and would be
demolished, however each family would
receive compensation. The officials
kept their word and the money soon
arrived. It was then that the
problems began...

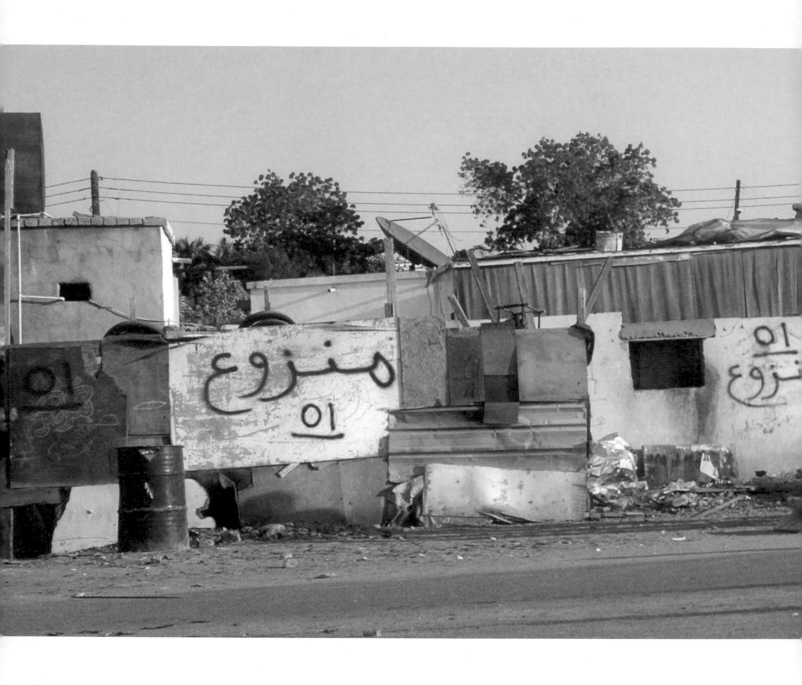

> *Manzoa* painted on buildings in Jizan

Most of these families had never seen so much money. It was a gift from God, they told each other. *Alhamdulillah*. Better yet, the local authority had not set a date for the demolition. Perhaps they would not get round to it, or just forget? Having agreed among themselves to stay put, the fishermen began to enjoy their new-found wealth. For most of them this meant one thing: more *qat*.

Qat is the semi-addictive narcotic hugely popular in neighbouring Yemen. It has a curious effect. On *qat* you do not want to move or eat. The only thing you want to do is talk, and when you get going you feel like Aristotle after a double espresso.

Qat took over their lives, and during the years that followed these fishermen and their families spent most of their compensation money. Once the money had run out they sold the piping that ran through their homes to buy more *qat*. Next to go were the roofs. Soon their electricity was cut off so they started to piggyback the supply that ran to the local mosque.

For years the bulldozers stayed away and nobody came, until several years later when a handful of official-looking men arrived with cans of red spray paint. As they moved away from their vehicles you could see them shake their cans up and down– *clacker-clacker-clacker-clacker*–before going up to each of the buildings in turn and–*hsssssss-sss-ssss*– spraying a single word repeatedly onto the concrete.

Manzoa. It means "about to be demolished," or "about to be removed." They wrote this on each of the illegal buildings before driving off.

Manzoa. Soon you will be gone.

On a warm evening in 2007 Captain Abdulnasser Gharem went for a drive. With him was the photographer Arif Al-Nomay. The two men were in Gharem's gargantuan 4 x 4 with its plush, fawn-coloured interior, a car that three years later would be sold to finance the production of the golden dome for *Message/Messenger*. They were prowling around in the hopes of spotting an unexpected opportunity to make art: a rupture in the ordinary scheme of things in which they could organise a performance or take photographs.

After several hours driving around Gharem noticed a shanty town of tired-looking buildings set back from the road. On the side of each was a single word: *manzoa*. There seemed to be people living there.

"Straightaway I had an idea," Gharem explains. "We drove to a shop nearby that sold paint. I bought a can of white spray paint. Like the ones we used for *Siraat*. I was wearing a red shirt, so I sprayed onto this the word *manzoa*. Then we went back to the buildings."

A game of football was underway. Gharem pulled on his *manzoa* shirt and joined in, sitting deep in midfield. This is his favourite position. It is where he can control the tempo of play.

"When they saw my shirt all of them wanted to talk to me. They asked about why I was doing this. I explained that it was a performance and that I would soon be gone. They liked it. So they told me their stories, about the compensation money, the *qat*, selling their roofs. I kept moving. Arif kept photographing. Both of us were *manzoa*."

The sky turned the colour of sand. It carried on through a darkening, crepuscular rainbow until the

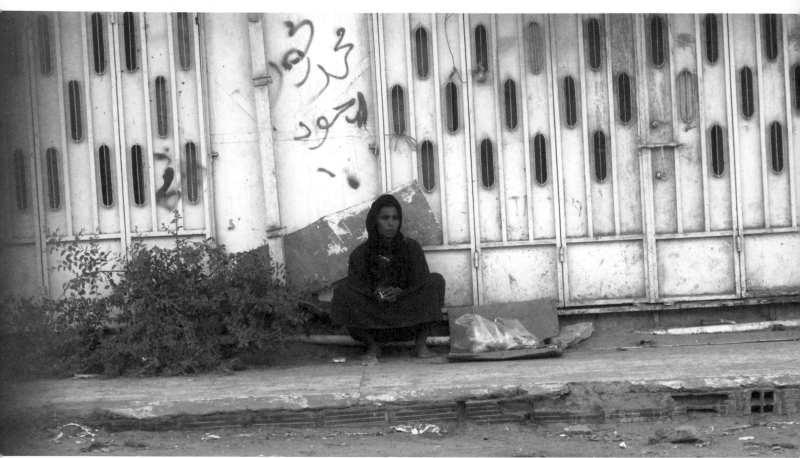

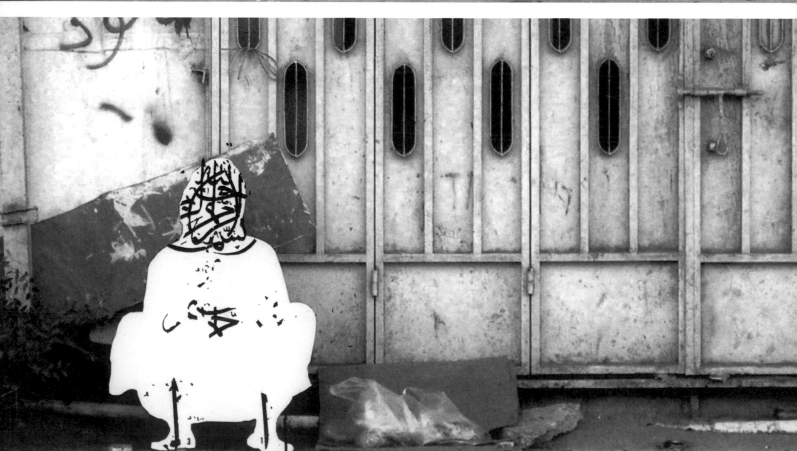

> Resident of Jizan (top), artist's collage (bottom)

moon rose up beyond the houses without roofs. Fires began to burn. The few people with any food cooked while the rest sank into a familiar pit of hunger and despair.

"Oh my God. At night this village became the saddest place I have ever known," Gharem would say of his stay. "The children start to cry and howl. There's no food. The fathers sit there chewing *qat*. They have no money. They will soon have no home. On their souls I could have written *manzoa*."

Later that night Gharem and Al-Nomay went back to Khamis Mushait.

As with *Siraat* and *Flora & Fauna*, in *Manzoa* we see Gharem propose and document an unofficial history. Here is a forgotten community that most of his compatriots know nothing about – nor do they necessarily *want* to know. Some would deny that these people even exist. Years later, when Gharem displayed photographs of *Manzoa* in London, one Saudi insisted that this scene could not have taken place in Saudi Arabia. There must be some mistake. Why? "Because," she said, "there are no poor people in our country."

Through his work Gharem navigates the no-man's land between the hidden areas of Saudi society and the country's official histories. But he does so without being antagonistic. It is courageous work, but it contains an implicit subtlety and at no point does Gharem end up intoxicated by the act of speaking out.

"I know this [performance] will not change their situation," Gharem explains. "But I also know the power of the image. It is important to show how these people are living. Otherwise we don't see them. Be interested in these people! That's what I am saying. Is it a kind of journalism? Why not? Also it is a documentary. But there is romance as well, and tragedy."

At the time, nobody in Saudi Arabia was making work like this. As the curator and international relations analyst Robert Kluijver explains, "what makes Abdulnasser's work so interesting is that he does not belong to a particular scene. As a performance artist he is in isolation. He follows his own path. But what you have to understand is that the absence of a thriving contemporary art scene in Saudi Arabia means that artists like him become more concerned with the question 'what is an artist?' Imagine how many people around them ask that question. For the artists, I think, the answer is to produce work that engages with their social and political environment. There is an emphasis on championing local issues. In Gharem's work you repeatedly find this element of journalism, particularly in *Manzoa*."

What separates his work from straight journalism is the frequent recourse to the poetic. While he has a journalist's eye for social injustice, he retains the poet's understanding and appreciation of that which is left behind: the remains. In both *Siraat* and *Manzoa*, Gharem brings out the wistful, pre-nostalgic meaning of the words he takes as his starting point. His presence in these and *Flora & Fauna* is at times ghostly, otherworldly; he is both there and not there.

"Certainly there are things you can allude to as a Saudi artist that you might not as a journalist,"

> Residents of Jizan in their roofless home

says Fady Jameel, President of Abdul Latif Jameel Community Initiatives. "The interpretation of these artworks is open-ended. So you can get away with more. I think this is why you find so many Saudi artists who are engaged with contemporary local issues."

In a different sense with *Manzoa*, Gharem moved beyond the conventional paradigm of an artistic performance. While those who witnessed *Flora & Fauna* gradually understood that this was an intellectual and artistic exercise, the fishermen and their families had no context in which to place this alien figure with *manzoa* written on his shirt. They did not agree to take part beforehand. Nor were they the unwitting victims of an artistic joke. Gharem's arrival was an invasion as much as a performance, and as such, it required guts. Ever the trickster, he slipped into this foreign territory disguised and uninvited. Yet he was accepted. The fishermen recognised the authenticity of his actions.

Manzoa says a great deal about courage as well as Gharem's ability to improvise. Within an hour of seeing the *manzoa* buildings he was among them, enacting a performance.

"I'm always rethinking," he once said. "And this is so important for me. I have no studio so my studio is wherever I can find people, or their trace. When I see the opportunity I must take it."

In *Chance and Necessity*, the Nobel Laureate and French biochemist Jacques Monod argues that only with "absolute chance,"—i.e. coincidence, contingency, the collision that occurs when two unrelated sequences join—do you find the possibility of "absolute newness." The possibility of this is all

very well, but it means nothing without a Gharem-like figure to take advantage of opportunities as they present themselves.

In 2008, the year following *Manzoa*, Gharem experienced a string of these unexpected collisions, each one a setback as much as an opportunity.

PLATES

PLATES 2

MANZOA
FLORA & FAUNA
DUNG BEETLE

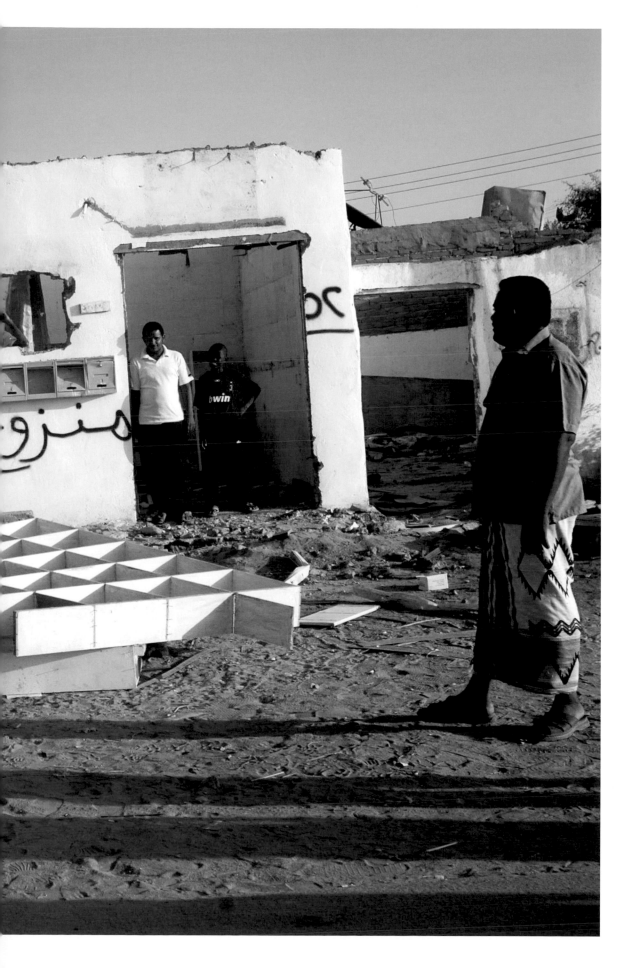

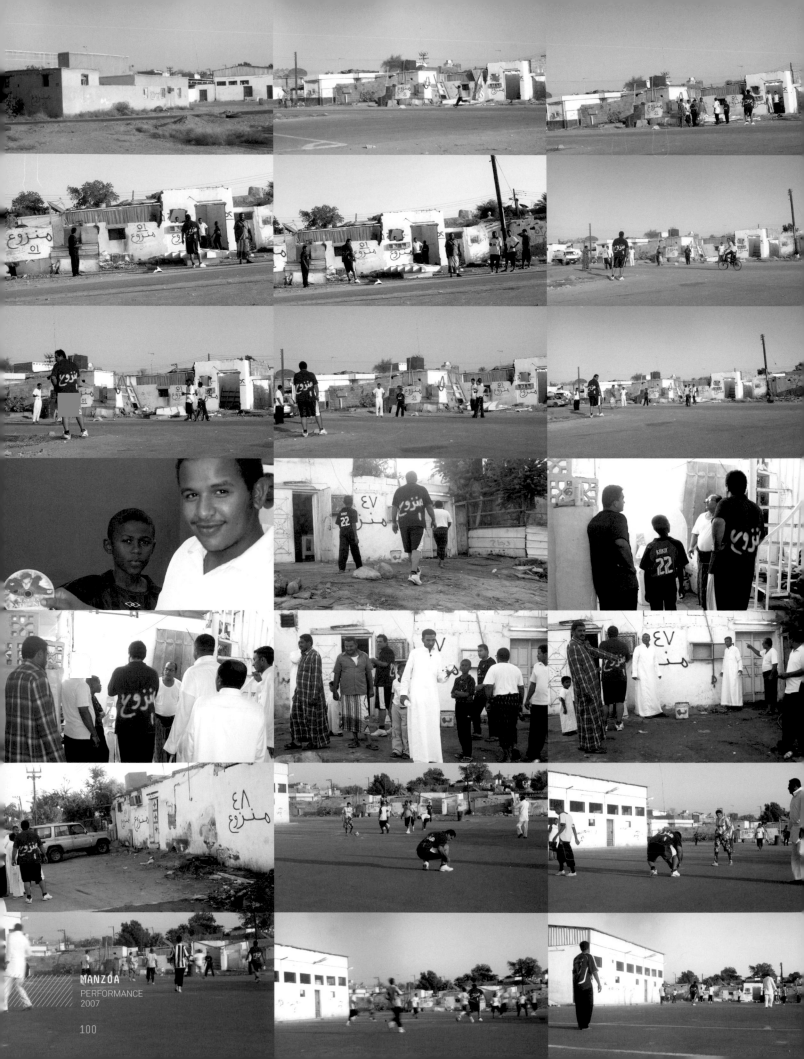

MANZOA
PERFORMANCE
2007

100

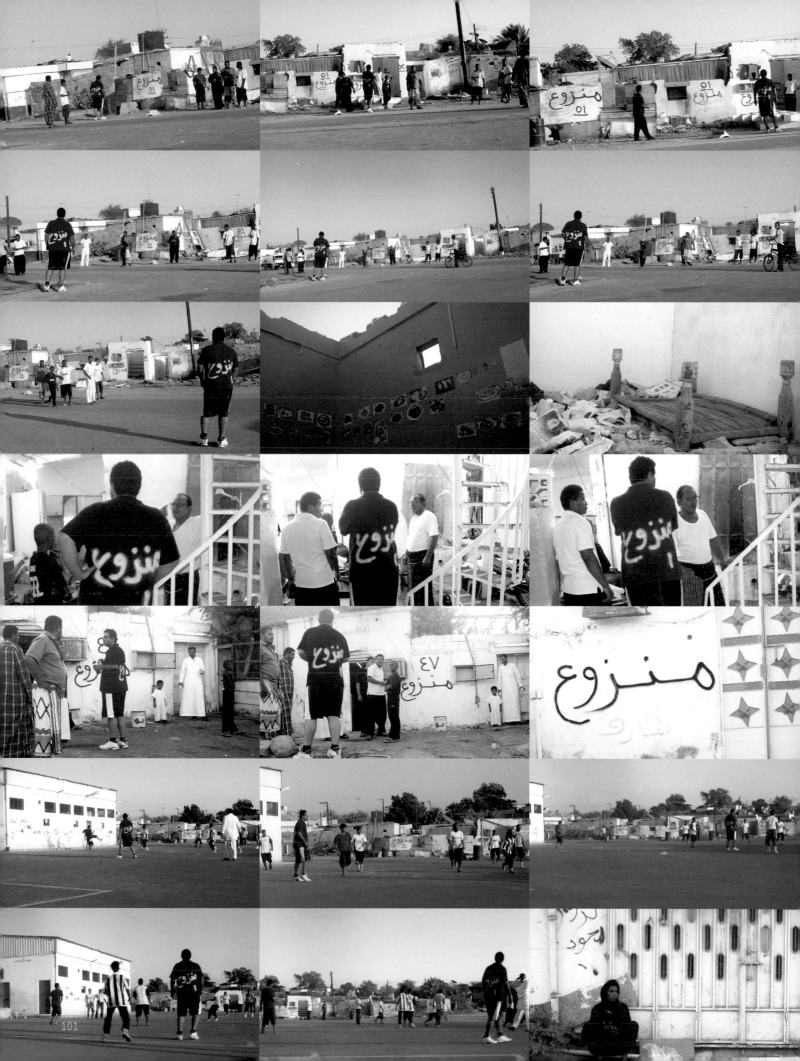

101

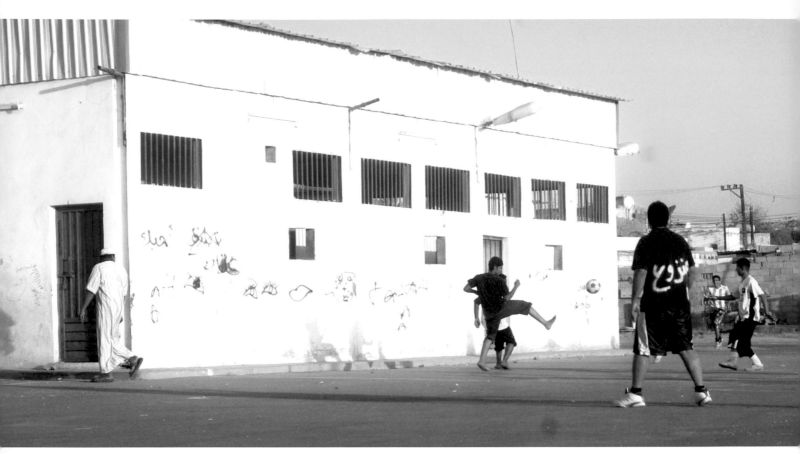

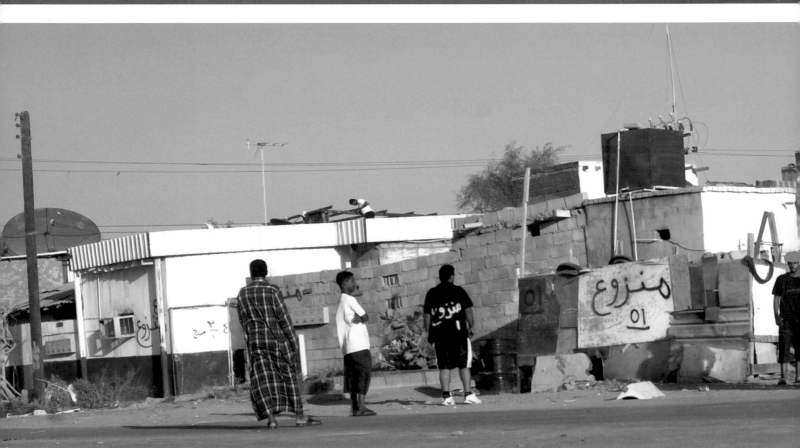

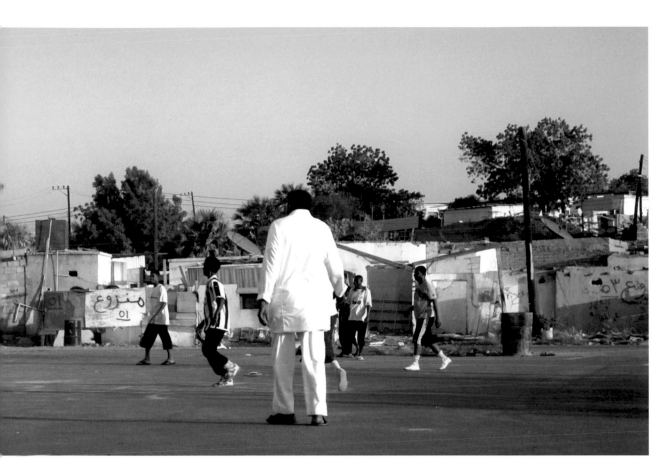

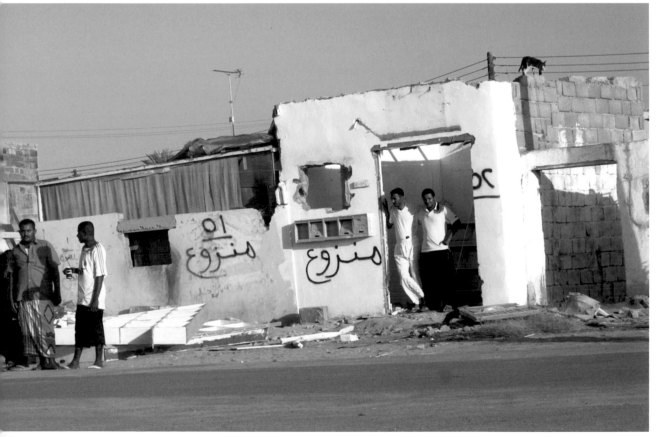

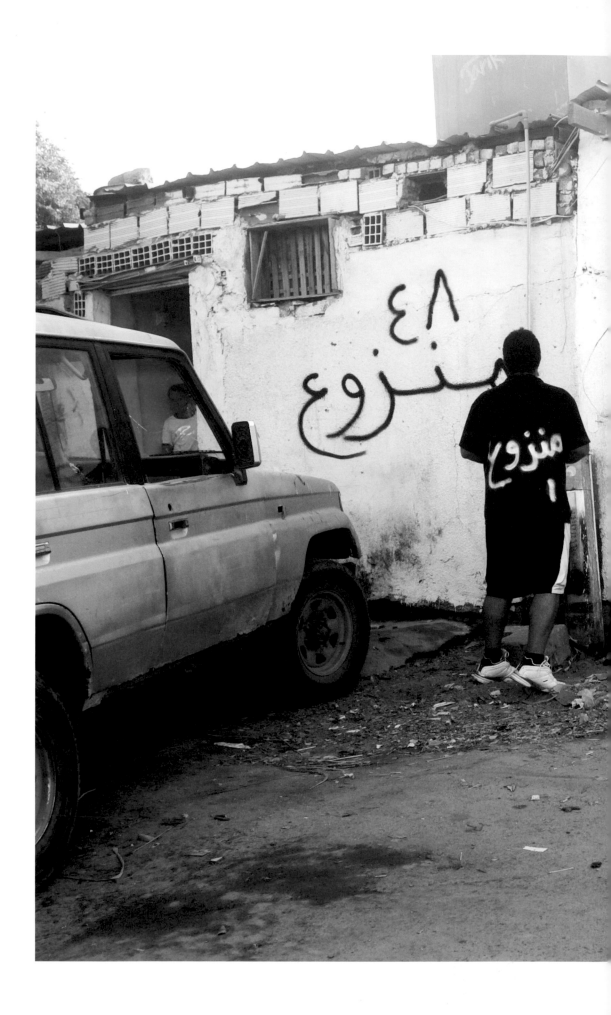

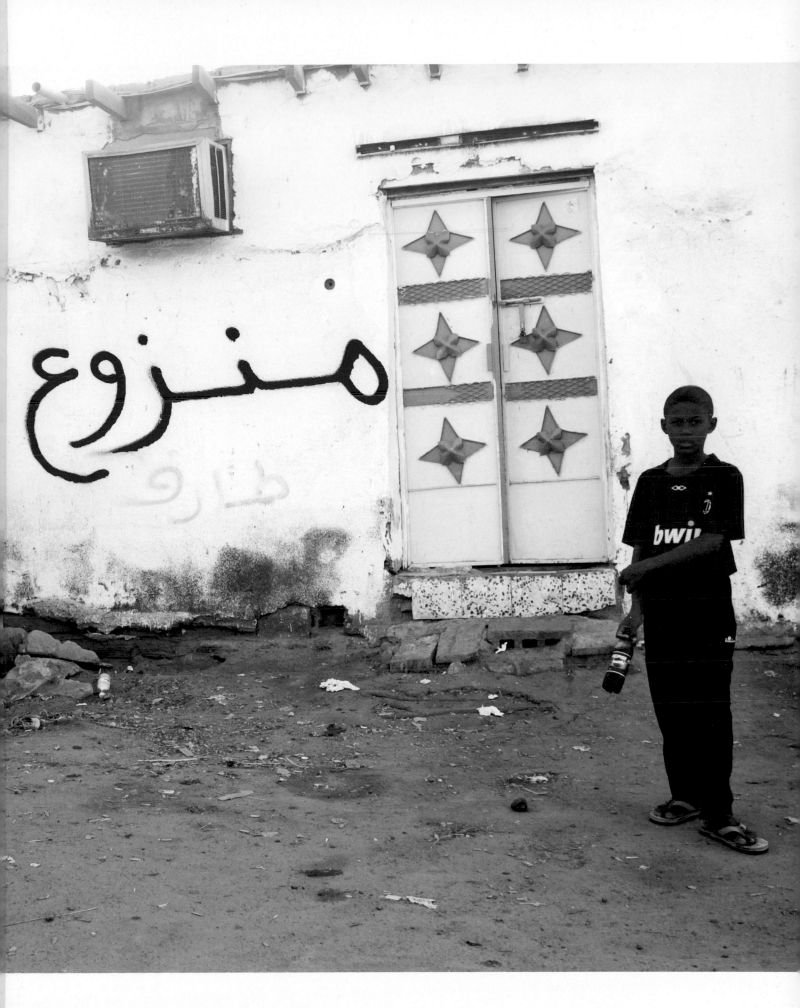

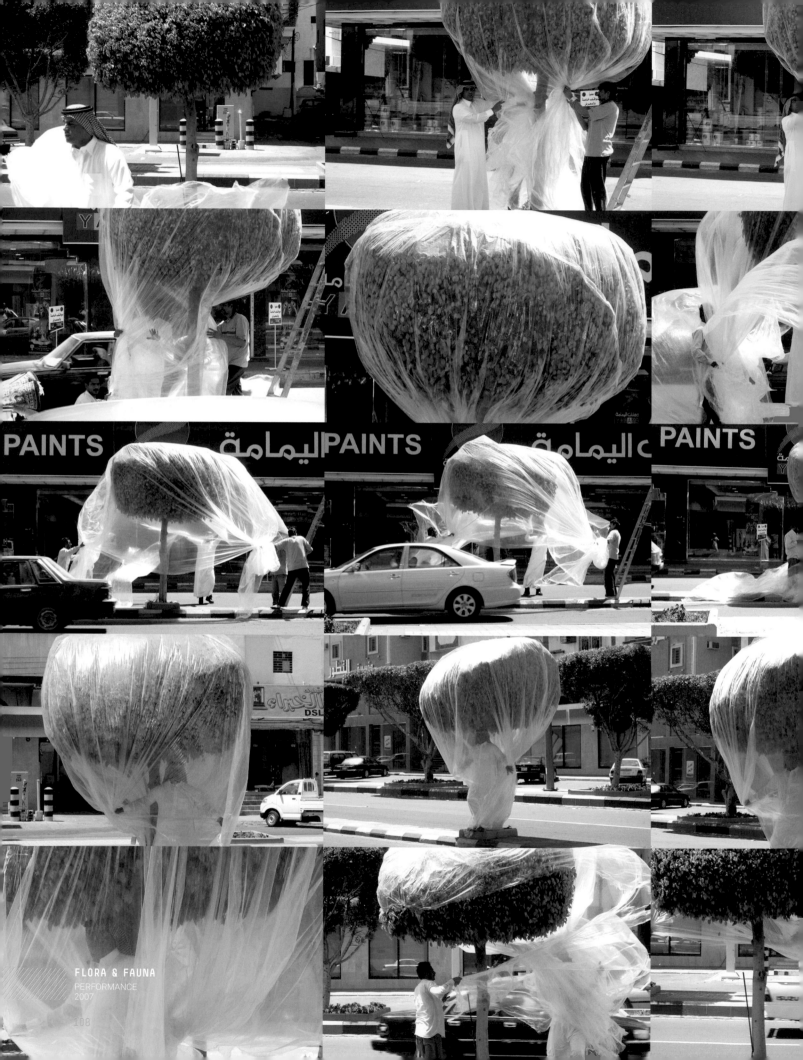

FLORA & FAUNA
PERFORMANCE
2007

108

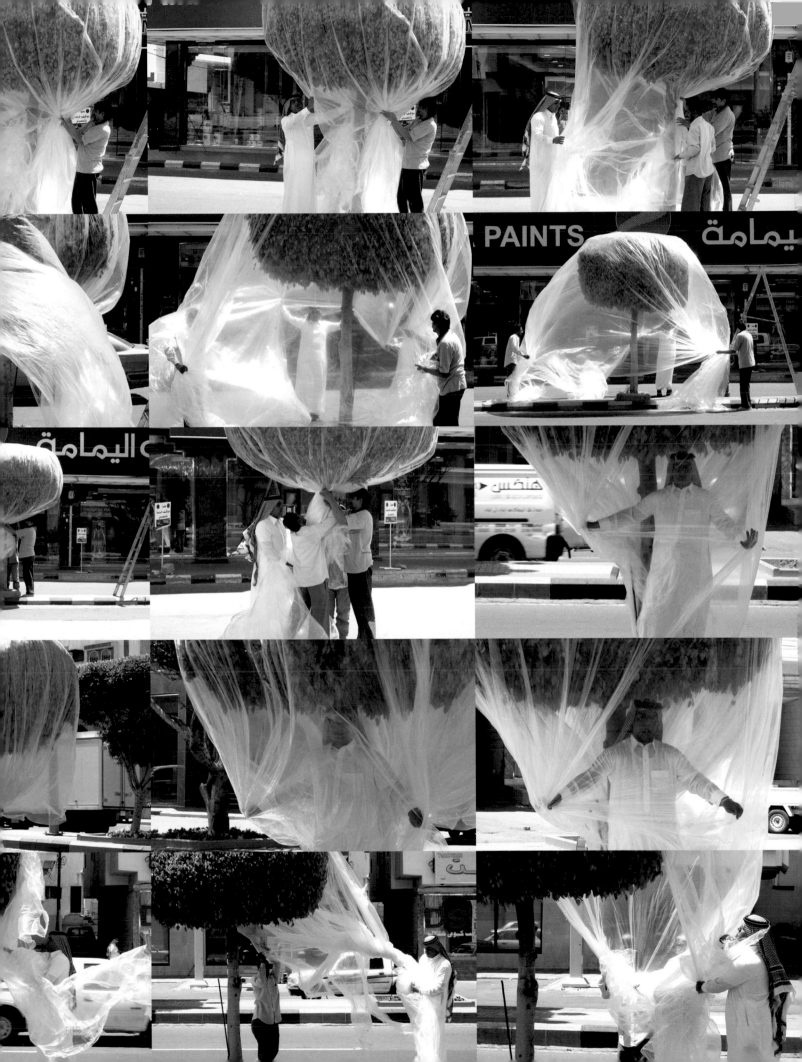

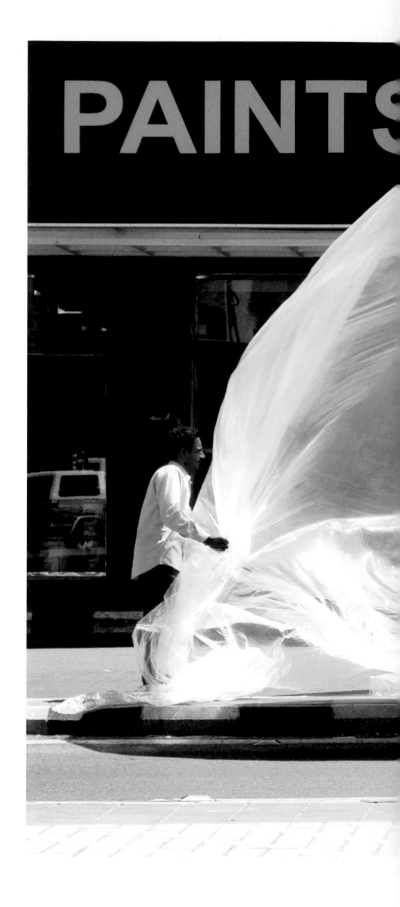

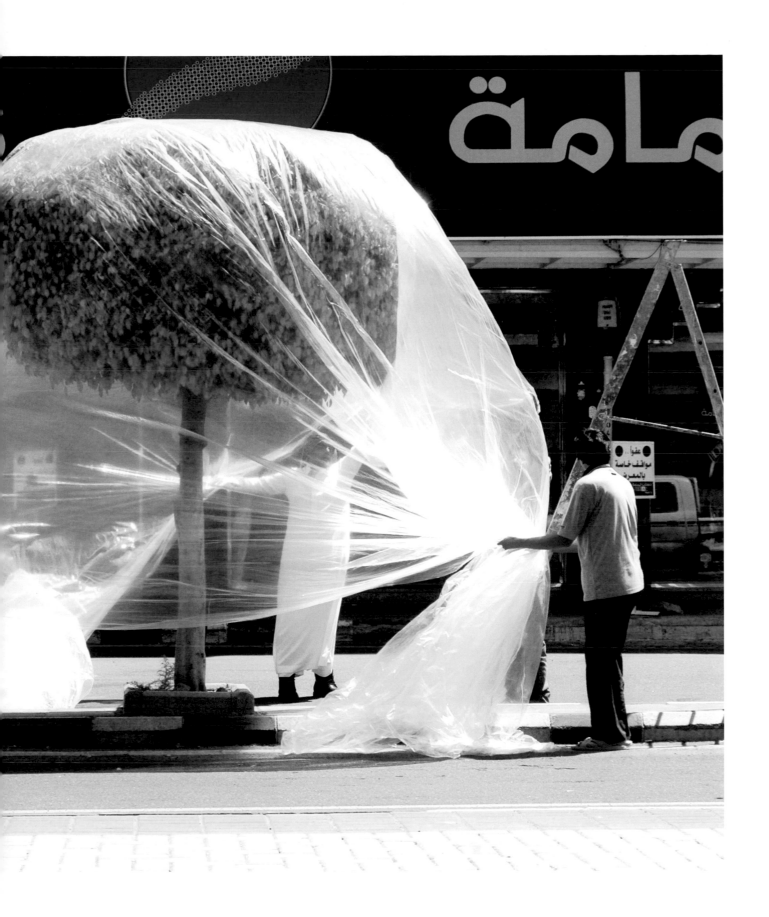

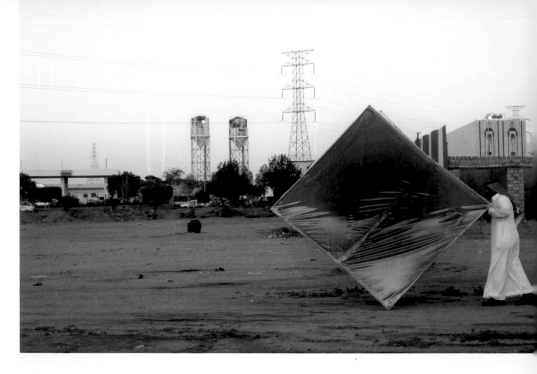

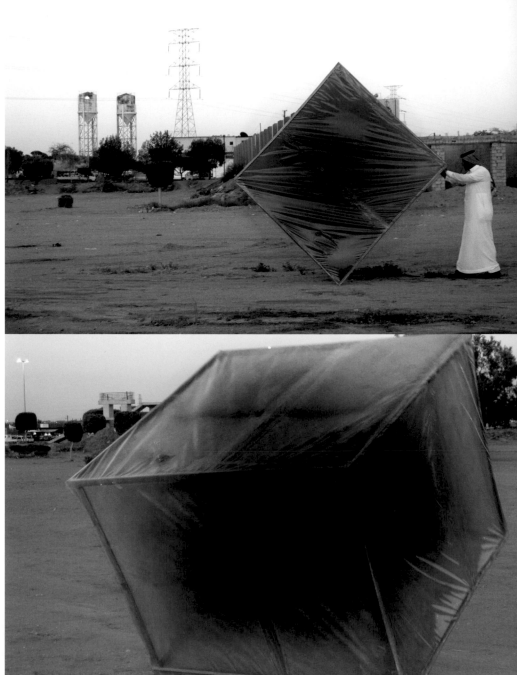

THE
STAMP

"Art is what you can get away with," Andy Warhol probably said. In the story of the days and months leading up to the opening of a group exhibition called Edge of Arabia in London, we have a neat account of what you could and could not get away with as a Saudi artist in 2008...

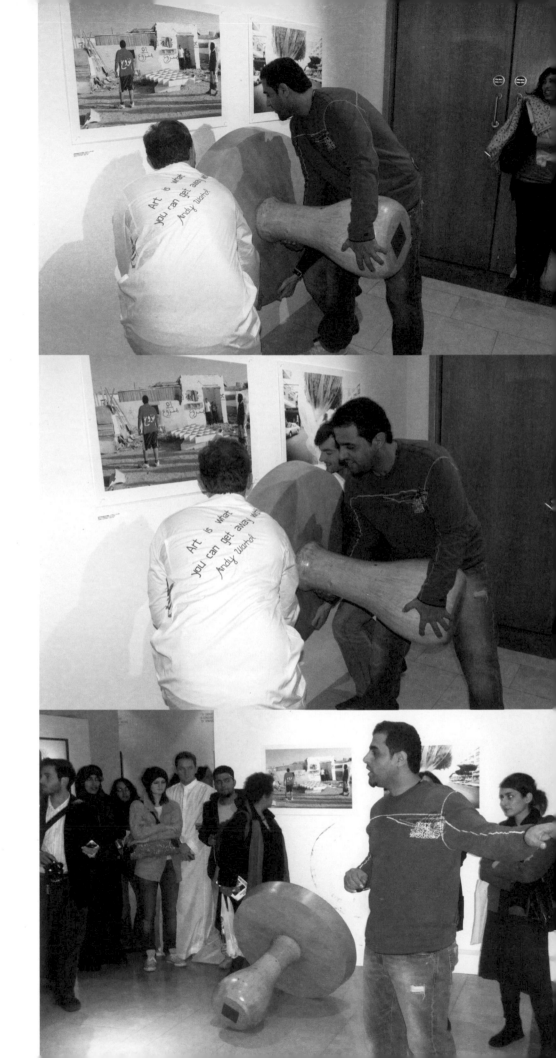

> Performance of *The Stamp (Amen)*
at the Brunei Gallery, London | 2008

This chapter is about censorship. Censorship of oneself, censorship of others, censorship as a stimulus, and how the boundaries of censorship evolve over time. Central to any understanding of this is the notion of *khutoot hamra*, or red lines: the bounds within which each Saudi operates, regardless of whether or not they make art.

Stephen Stapleton's first visit to Al-Meftaha Arts Village back in 2003 marked the beginning of a long and fecund collaboration that led to the group exhibition and accompanying book *Edge of Arabia*. This was set to be the first international and comprehensive display of 21st century Saudi Arabian contemporary art. It would feature the work of seventeen Saudi artists and was due to open in October 2008 at the Brunei Gallery in London, part of the School of African and Oriental Studies (SOAS).

For most of the artists involved this was a gilt-edged opportunity. As Christie's Isabelle de la Bruyère remembers, "Edge of Arabia was tremendously important in promoting many of these artists. I remember seeing their first show in London in 2008 and being astounded by the many great works on display. Since, I have been following the local art scene as closely as possible." Gharem was looking forward to it as much as any artist would to their first London exhibition, and as one of the founders of the Edge of Arabia initiative he had been asked to show two works: *Manzoa* and *Siraat*.

With four months to go the curators drafted a press release and chose *Siraat* to accompany their text. It was an iconic image, one that seemed to capture people's imagination.

Before it was sent out, a draft of the press release was circulated among those connected with the exhibition. Unfortunately it contained a mistake. The caption to *Siraat* implied that the writing on the remains of the bridge included Qur'anic verses. As we know, it did not. The mistake was corrected, but this was not the end of it. Instead word began to spread that Edge of Arabia included an artwork in which Qur'anic text had been transposed onto a road. Part of the imagined offence was that both feet and cars were rolling over the word of God.

This was wrong on two counts. The bridge was no longer a road, and Gharem had not replicated any verses from the Qur'an. Yet the pressure began to mount on the curators to remove the offending artwork. Even Gharem began to feel this pressure back at home.

"I have always been proud of his art," says Gharem's father, "but when I saw the Shattah exhibition I was a little worried. When I heard about *Siraat* I was more worried. I told him, 'Abdulnasser, you're a military man, an officer. Some people may look at this and interpret it in different ways. They might see things in it that you did not intend. Be careful.'"

Back in London the exhibition curators mulled over whether or not to include *Siraat*. The argument against inclusion was simple: it *might* offend an extreme religious sensibility. This was not argued from a position of religious authority and nobody who had seen *Siraat* had been upset by it. The decision was based on subjective calculations of a worst-case scenario.

With three weeks to go Gharem was told that *Siraat* would be excluded from Edge of Arabia. This decision was later picked up by the British media. In *A Degree of Influence*, a report published the following year by Robin Simcox for the Centre for Social Cohesion, the exclusion of Gharem's *Siraat* was described as an act of "censorship," and a "remarkable" decision, given that this particular gallery "should be a bastion of free speech." [7]

Nonetheless the decision stood, and the curators wrote to Gharem asking if there was another piece he could contribute instead.

No, was the immediate response. His studio was empty.

"It took me years to come up with *Siraat*," he told them. "How can I find another idea in just three weeks?"

During the next week there was radio silence between London and Khamis Mushait.

Earlier that year Gharem had been made a Major. What did this mean in practical terms? A bigger salary, for one, more responsibility, and many more hours behind a desk. He had more forms to plough through,

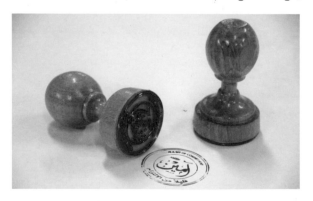

more administration to deal with, and otherwise more slips of paper to stamp.

Gharem was interested in these stamps. No matter how complex the logic that informed his decisions, these stamps reduced his thoughts to a single stab, a binary 'stamp' or 'no-stamp'. Each day in Saudi Arabia thousands of stamps are slammed down onto a mosaic of official papers by bureaucrats, officials, policemen and soldiers, and together they articulate an unconscious and collective imprimatur. They spell out what is acceptable, or which is the 'right path'.

This gave him an idea. He went to the family furniture workshop where he had made portraits as a teenager and showed one of these stamps to a craftsman. If Gharem provided the materials, could he make a giant, scaled-up version of this stamp out of solid, turned wood? Probably. Would it be ready in two weeks? Wince, frown... smile. *Inshallah*.

Next he found a factory that could produce a circular slab of rubber for the underside of his oversized stamp. The text would be simple, "Have a Bit of Commitment," followed by "Amen," written both in English and Arabic.

One rubber stamp was good. But how about a bed of thousands of the interchangeable letters that make up the underside of some rubber stamps? With the construction of the giant stamp underway Gharem began to buy as many children's printing kits as he could find. In each was a small set of rubbery Arabic letters, numbers and numeric functions. Once he had amassed several hundred of these, he packed together the letters until he had two flat surfaces, each one gunmetal grey and full of undulating, bureaucratic detail.

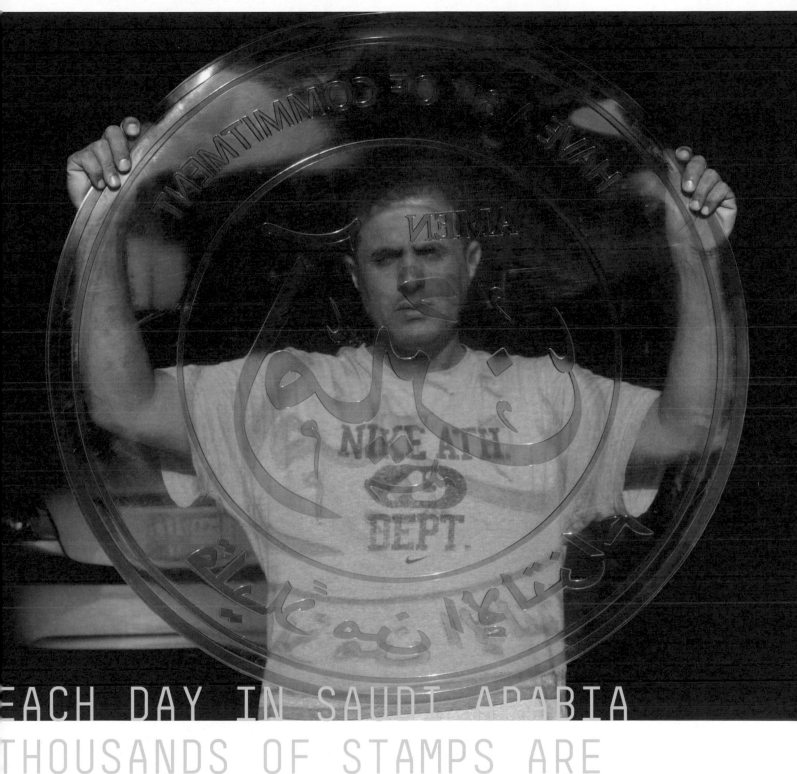

EACH DAY IN SAUDI ARABIA
THOUSANDS OF STAMPS ARE
SLAMMED DOWN ONTO A MOSAIC
OF OFFICIAL PAPERS

> The artist with embossed
rubber for *The Stamp (Amen)*

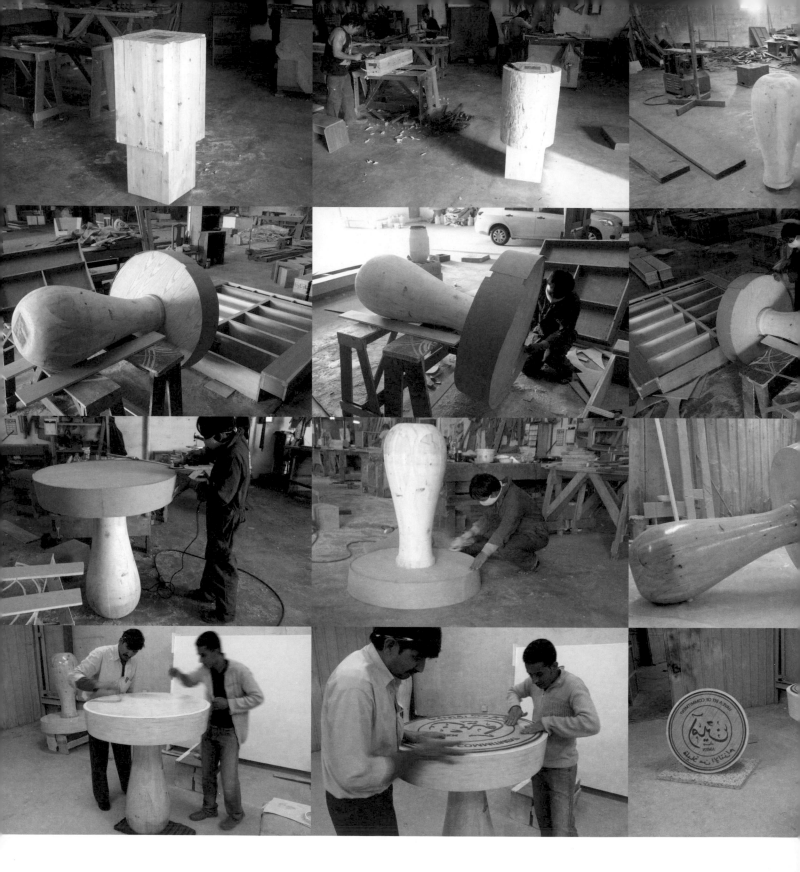

> Construction of *The Stamp (Amen)*

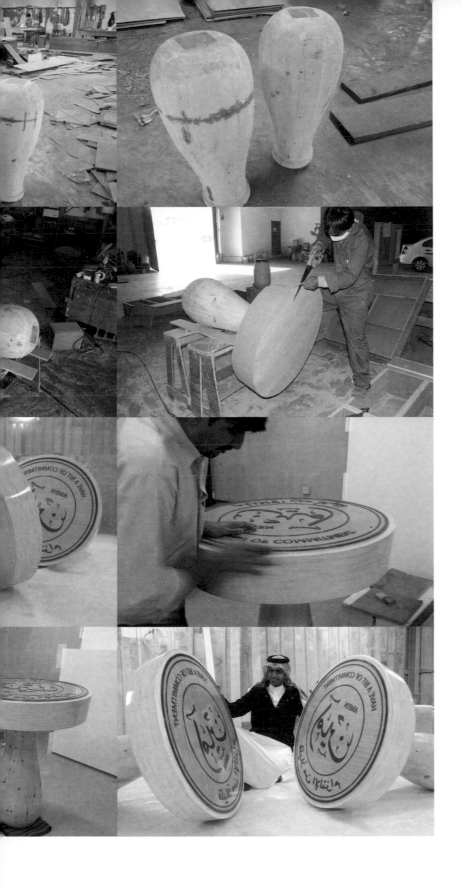

121

IT SUDDENLY BECAME CLEAR
THAT THOSE TWO CHARCOAL
RECTANGLES REPRESENTED THE
WORLD TRADE CENTER WITH A
PLANE ENTERING ONE
OF THE TOWERS

"The feeling I had at the time was that it was impossible to change the minds of all the people against *Siraat*. Together they formed a wall. A system. The system did not have a human face, but it had created a stamp of disapproval. It can be very hard to defend yourself against this."

Onto one of the two rubbery beds destined for London, as well as the yellow stripe of the road in *Siraat*, Gharem painted a pair of dark rectangles using industrial lacquer paint. Near the top of one he added what looked like an arrow or a plane.

With ten days to go before the opening of Edge of Arabia Gharem packed the two pieces off to London. These 'stamp paintings' became the starting point for a new series he called Restored Behaviour. The giant wooden stamp was taking longer to finish and would have to be transported to England by hand.

"I remember the stamp paintings arriving in London," recalls Stapleton. "They were a complete surprise. It was as if we had been sent a code. I felt Gharem was challenging us as curators. Immediately I recognised elements of *Siraat* in them, with the yellow stripe of the road, and the grey of the concrete. But that was it."

It was not until these works were hung on the wall that the meaning of one of them was transformed.

"It turned out we had been looking at them the wrong way up," says Stapleton. "When they were up on the wall it suddenly became clear that those two charcoal grey rectangles represented the World Trade Center with a plane entering one of the towers. My first reaction was panic. Panic followed by intellectual excitement."

For Stapleton and the other curators it seemed that Gharem had addressed the elephant in the room. He had gone to the heart of the matter and he had done so with conviction. They hung the stamp paintings and awaited Gharem's arrival. By the time he got to London, two days before the show opened, the curators had been asked to remove from the exhibition Gharem's stamp painting containing the twin rectangles.

"This was difficult for us," says Stapleton. "Edge of Arabia was not in any way critical of Saudi Arabia, but at the same time it was not about promoting a particular public image of the country. Its focus was simply to create a platform for the new generation of Saudi artists. Ultimately, we knew that this was the first step in a long process, so it had to go."

Rather than have his stamp painting removed from the show, Gharem offered to adjust it. He bought some grey paint and added a third rectangle before giving it a new title: *Pedestrian Crossing*. It remained in the show.

There was more. On the evening before the opening, following an official visit to Edge of Arabia, Gharem's photograph of *Manzoa*, that showed him moving among the roofless slums of Jizan, had vanished.

"When I heard that *Manzoa* had disappeared I was so pleased," says Gharem. "Really. I knew that my job was done. These works had moved the people who saw them. So they hid them. I don't blame them for what happened."

On the day of the opening of Edge of Arabia the *Manzoa* photograph was found. It had been hidden within a neighbouring installation, and just in time for

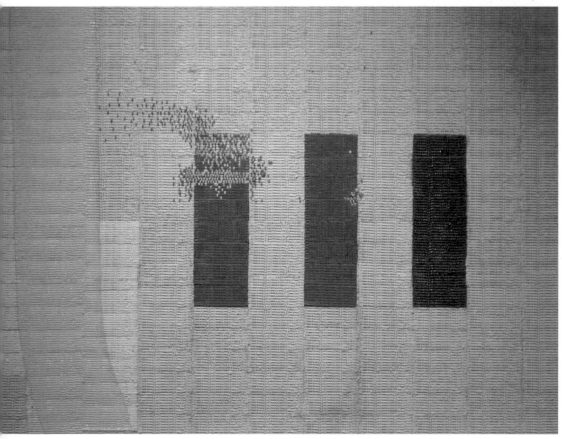

PEDESTRIAN CROSSING
INDUSTRIAL LACQUER PAINT ON RUBBER
STAMPS (ON 9MM INDONESIAN PLYWOOD)
H95 x W120 CM
2008

PEDESTRIAN CROSSING
WITH ADDITION OF THIRD STRIPE
2008

> The artist with *The Stamp (Amen)*,
Jeddah Airport | 2008

the opening it was restored to its original position on the wall.

By now Gharem's enormous rubber stamp had arrived. To mark the opening of Edge of Arabia Gharem inked up the stamp, and with the help of two others (including this author) it was charged onto the walls of the gallery like a medieval battering ram.

He called this action *Have a Bit of Commitment*. It remains one of his most potent and precise works. By applying his giant stamp to the gallery walls Gharem had in a way authorised the exhibition. While the authority of a bureaucratic stamp derives not from the person using it but the institution to which he or she belongs, Gharem represented no body other than his own corporeal self. With *Have a Bit of Commitment* Gharem proposed and enacted a separate authority—that of an author or an artist— and it was this that became the final authority in this protracted transaction between Gharem and those who did not want to see his work on show.

Unlike so many other stamps, Gharem's articulated more than a 'yes' or 'no', 'approve' or 'disapprove' response. His message was "have a bit of commitment," have a bit more intellectual rigour, more bravery, more confidence in your convictions. It is a sentiment that might sound reckless but for the final word: "Amen." This acts as a stamp of approval on the stamp of approval.

"In those opening few days of the exhibition Abdulnasser really stood out," says Stapleton. "More than any other artist he saw this exhibition as a chance to develop his work. He was not at all passive. I think he had begun to see the discussion and dissection of his work as an important part of the process. He set up interviews

with the local and national press. His voice was heard. I think the British audience really took to his work and engaged with it more than the other artists there."

When a senior academic stood up during an Edge of Arabia press conference and began to describe the work on show as merely mimicking western art, it was Gharem who got up to interrupt him.

"I told him and the people listening that this work was not western. It was modern. There is a difference. We were using the available media to construct a Saudi Arabian understanding of contemporary art. This was ours. Not theirs. Eventually he agreed."

On his return to Saudi Arabia Gharem set about restoring the reputation of *Siraat*. He began by contacting an array of Saudi newspapers, magazines and television channels, asking them to run features on *Siraat*. There followed coverage in *Gawasil*, *Al Watan*, *What's Up Jeddah*, *Al Riyadh* and *Al Jazeera*.

> *Siraat (The Path)* featured on the covers of *Deutscher Kulturrat* (German Cultural Council newspaper) and *A Degree of Influence* (report by the Centre for Social Cohesion)

As he had predicted, *Siraat* was not met with howls of outrage. It was not religiously or morally subversive and Gharem knew this just as he understood how press coverage could, in itself, validate and provide an informal sanction. As he would do repeatedly in the coming years, Gharem used the media as an unofficial stamp of approval for himself and his work.

The following summer, in 2009, a reduced version of the Edge of Arabia exhibition appeared at the Palazzo Contarini dal Zaffo in Venice, to coincide with the 53rd Biennale. One of Gharem's contributions was the video of *Siraat*. Dr Abdulaziz Al-Sebail, Deputy Minister of Culture for Saudi Arabia, came to see it.

His reaction was emphatic. He watched it back-to-back seven times, before telling Gharem it was one of the most powerful things he had ever seen. Al-Sebail described Gharem as "one of the leading artists in Saudi Arabia and someone we [at the Ministry of Culture and Information] believe in very much."

The acclaim poured in. Dr Venetia Porter, Assistant Keeper of the British Museum's Islamic and contemporary Middle East collection, described *Siraat* as "so evocative and powerful." By now photographs of the piece were in collections in Amsterdam, Germany, the United States and Saudi Arabia. Robin Start, of London's Park Gallery and Curator of the first Saudi National Pavilion at the 54th Venice Biennale, described Gharem as "without doubt the leading conceptual artist in Saudi Arabia today."

What do Gharem's experiences between 2008 and 2009 tell us about life as a Saudi artist in the early 21st century? It suggests there are limits to what you can get away with, as Warhol put it, but these limits are fluid and non-statutory. By proposing *Siraat* for Edge of Arabia London, Gharem had not broken a British or Saudi law, nor had he challenged an established taboo, *hadith* or Qur'anic *aya*. Artistic censorship of Saudi artists, such as it is, will be influenced as much by religious interpretations as customs, politics, subjective understandings, misunderstandings, established norms and recent statements from local sheikhs or members of the government.

During the first decade of the 21st century, just as there was an evolution of the red lines within which Saudi artists operated, Gharem reached his artistic maturity. This echoes the broader shift away from the *Sahwah* of the 1980s and 1990s. But it was a gradual shift, at all times steady and considered.

This new direction was given added impetus by the accession of King Abdullah in 2005. The Custodian of the Two Holy Mosques, as he is also known, has encouraged artistic expression in Saudi Arabia as well as debate, national dialogue and improved rights for women. He has begun to lay the foundations for the institutions of civil society. The fact that the changes he might like to see have not happened overnight is a reminder of the size and heterogeneity of Saudi Arabia, and of the fact that this state is not a totalitarian autocracy.

Otherwise, what does this chapter tell us about Gharem's role in the changing face of Saudi contemporary art?

"For me, Abdulnasser is one of the leaders within a group of exciting young artists in Saudi Arabia," says Hamza Serafi, Director of Jeddah's Athr Gallery, the man who personally couriered *The Stamp (Amen)* from

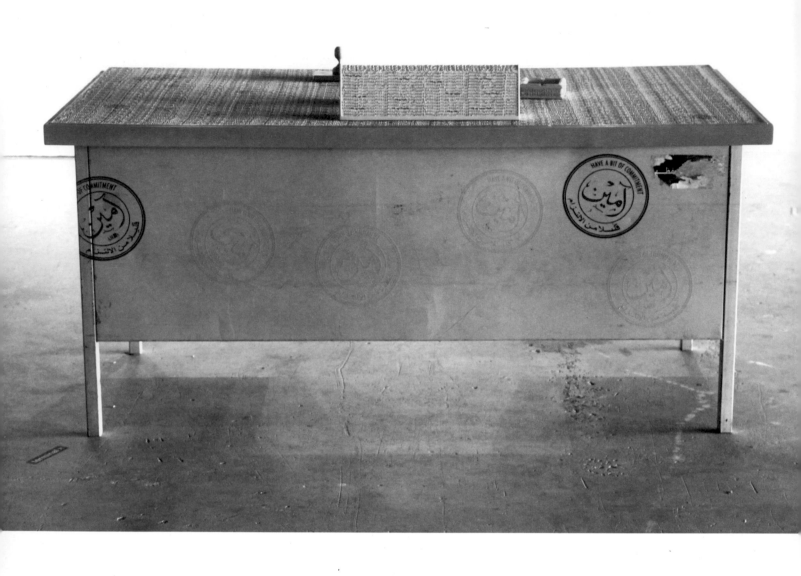

Jeddah to London. "There are others around him, of course, let's not forget them, but he is the one who is really pushing things on in terms of what you can show today in Saudi Arabia."

Fady Jameel echoes this, describing him as "the spearhead." He goes on to say: "The way Abdulnasser has pursued his artistic career provides a great example for other Saudi artists. He represents a new entrepreneurial spirit. This is the kind of creative ingenuity we are seeing a lot more of in Saudi Arabia today."

"At the same time," says curator and collector Basma Al-Sulaiman, "let's not see Abdulnasser as the Saudi equivalent of the dissident Chinese artist Ai Weiwei. That would be a mistake. Abdulnasser is not opposed to the government. Though he is disciplined and courageous he is not aggressive and he is not trying to break the rules. He has conviction, yes, but he has subtlety too and respect. In Saudi Arabia it's hard to achieve anything without these. That's what's so clever about him and his art."

The work Gharem has shown—or tried to show—has accelerated ever-so-slightly the gradual revision of what constitutes acceptable visual culture in contemporary Saudi Arabia. More than any of his peers, Gharem's work is positioned right up against those red lines. Yet Al-Sulaiman is right: you cannot get this close without subtlety and respect. What Gharem has achieved also gives us an insight into the nature of these red lines. To an outsider they are immutable. To a Saudi, they are delicate, papery things that can be manipulated – but only with great care.

Push too hard and you end up tearing through, achieving nothing. In Gharem's work, the way he describes it, and the media attention he generates, you can see how this is done. His practice is testament to the art of pushing without pushing too hard. *Have a Bit of Commitment* and his response to what happened in London in 2008 are both vivid embodiments of this.

CONCRETE

Between 2003 and 2005 Saudi Arabia experienced a wave of terrorist attacks. They have since been referred to collectively as "the Kingdom's 9/11."[8] The men responsible were jihadis who had fought in Afghanistan, and most were Saudi nationals. Their targets were often fortified compounds that housed foreign workers, both western and Arab. As well as suicide bombings they carried out executions of petrochemical employees, technicians, and in one incident they targeted journalists, killing the BBC's Simon Cumbers and leaving his colleague Frank Gardner partially paralysed...

"FEW WILL HAVE THE GREATNESS
TO BEND HISTORY; BUT EACH OF
US CAN WORK TO CHANGE
A SMALL PORTION OF EVENTS,
AND IN THE TOTAL OF ALL
THOSE ACTS WILL BE WRITTEN
THE HISTORY OF THIS
GENERATION […]. EACH TIME A
MAN STANDS UP FOR AN IDEAL,
OR ACTS TO IMPROVE THE LOT
OF OTHERS, OR STRIKES OUT
AGAINST INJUSTICE, HE SENDS
FORTH A TINY RIPPLE OF HOPE,
AND CROSSING EACH OTHER FROM
A MILLION DIFFERENT CENTRES
OF ENERGY AND DARING, THOSE
RIPPLES BUILD A CURRENT WHICH
CAN SWEEP DOWN THE MIGHTIEST
WALLS OF OPPRESSION
AND RESISTANCE."

> Robert F. Kennedy, University of Cape Town, South Africa | 1966

In response to these events, the physical complexion of Saudi Arabia began to change. Barriers appeared in their thousands outside embassies, large hotels, foreign compounds, the offices of conglomerates and government buildings. These barriers were usually made up of interlinked concrete segments, each one a bottom-heavy lump with a triangular skirt to keep it pinned to the ground. To make these buildings more secure countless roads were blocked, creating detours and diversions.

In 2009 Gharem began to apply the logic of his initial stamp paintings to these concrete barriers and the concomitant detour signs that had appeared nationwide. As with *Siraat*, again Gharem wanted to examine the consequences of placing your trust in concrete.

"Concrete walls like this appear not just to protect people," he says, "but to keep knowledge and ideologies separate from one another. Look at the Berlin Wall, or the walls that went up in Baghdad to keep the Sunni and Shi'a apart. Does concrete protect you? Not always. We should be educating people, giving them opportunities, not building these barriers. My message is simple: don't put your trust in concrete."

It is interesting to note that Gharem's point of reference here is not the barrier established by the Israeli government in the West Bank / Judea and Samaria / Occupied Palestine.

"Perhaps for other people this is the only wall to talk about," he says. "But I'm not against the Israeli people. I'm not against anyone! I'm *with* the subject. What interests me here are concrete walls, what they keep out. In Berlin, yes. In Baghdad, yes. In Israel and Palestine, sure. But most of all it's the concrete barriers in my town and in my country that I'm interested in."

Gharem began to coat life-sized replicas of these concrete blocks with rubber letters, creating actual walls of bureaucracy. When he came to exhibit them he made sure they were positioned at the entrances to the exhibition spaces. Rather than keep anyone out, his barriers merely diverted the direction of human traffic.

"These walls are temporary," says Gharem. "We should see beyond them. An important speech I read at the time is the one given by the American Senator Bobby Kennedy."

This was Kennedy's legendary Day of Affirmation speech given at the University of Cape Town in 1966, in which he says:

"Few will have the greatness to bend history; but each of us can work to change a small portion of events, and in the total of all those acts will be written the history of this generation [...]. Each time a man stands up for an ideal, or acts to improve the lot of others, or strikes out against injustice, he sends forth a tiny ripple of hope, and crossing each other from a million different centers of energy and daring, those ripples build a current which can sweep down the mightiest walls of oppression and resistance."

Concrete Block IV is the apotheosis of this body of work. It comprises an eight-foot-tall barrier-segment covered in tens of thousands of rubber letters. No longer part of a wall, it has been transformed into a totemic monument. Rather than halt the flow of human traffic it inspires circumambulation. The viewer becomes a pilgrim to this iconic impediment.

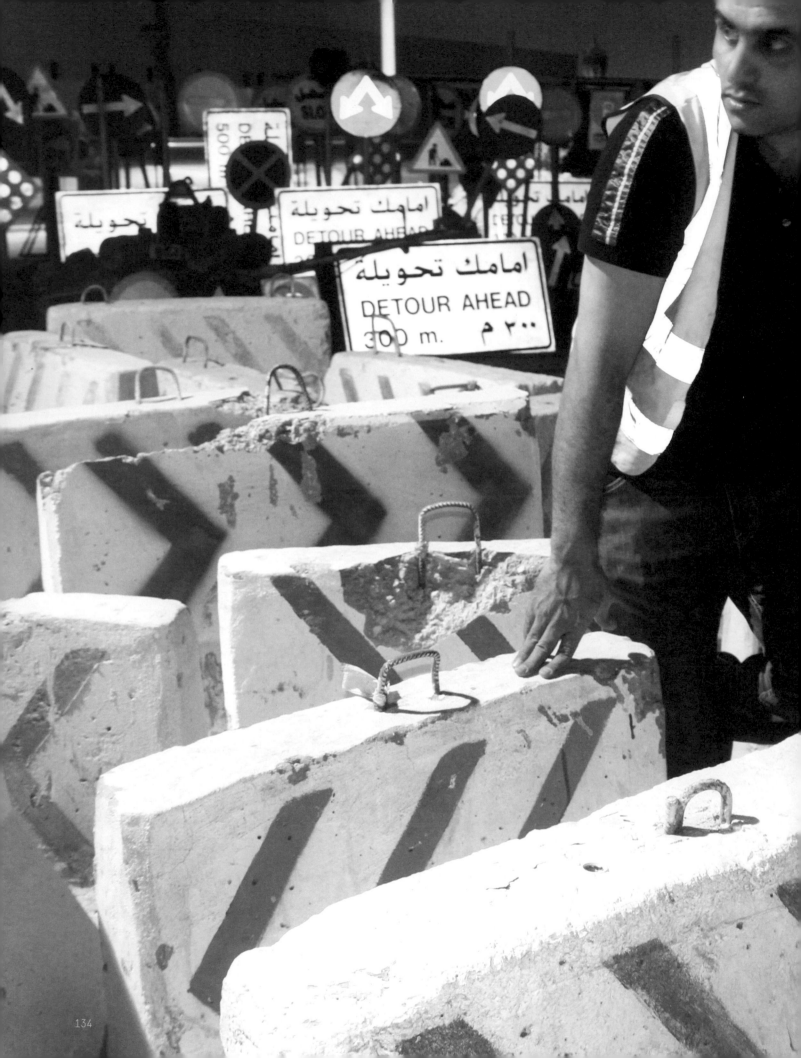

"For me," says Basma Al-Sulaiman, "this piece is about more than bureaucratic barriers and Saudi Arabia. It is about the barrier that each of us has in our heart. The places that we try to keep ourselves away from."

During this period Gharem also stepped up the production of his two-dimensional stamp paintings. He developed both the language and the medium, so that each was now interpolated with snippets from Kennedy's speech as well as aphorisms, slogans and fragments of poetry. Onto one went a portrait of the Palestinian poet Mahmoud Darwish. Elsewhere there were soldiers, religious geometries, a passenger plane caught at the point of departure, and a variety of road-signs indicating a delay or an unexpected departure from the norm. He also began to incorporate lit-up versions of Detour signs. In *No More Tears IV* this well-known shampoo slogan forms a reddish halo behind a picture of American President Barack Obama.

"President Obama gave a speech to Muslims in Cairo in 2009 in which he promised the Arab world many things," Gharem says. "He promised us peace in the Middle East and that there would be no more tears. We were waiting for all this, but it never happened."

This body of work is shot through with a sense of expectation, queuing, being placed on hold and waiting for a future event whose shape and form remain elusive. In *No More Tears IV* Gharem includes the message "No or Bad Signal." This is the banner that appears on your screen when an internet connection fails. Just as many Arabs around the Middle East were still hoping that Obama's promise would come true, in this piece a state of limbo is played out before

the wall. The way is blocked so it is necessary to take a different route, a detour that is as unplanned as it is interstitial.

If before Gharem had focused primarily on social environments ear-marked for destruction, positioning himself as a virtual *rawi*, now he had re-adjusted his gaze, and his subject was the wall of bureaucracy faced by those inhabiting these liminal states. He had begun to look at notions of Kafkaesque impenetrability as signified and enforced by the appearance of concrete barriers. This new body of work also articulated with greater emphasis Gharem's response to the two Gulf Wars.

"I am a post-war artist," says Gharem. "The first time I made abstract paintings was after the first Gulf War. I made *Siraat* immediately after the invasion of Iraq in 2003. I wanted to bring out the feeling of being helpless in the face of an enormous force – an enormous force

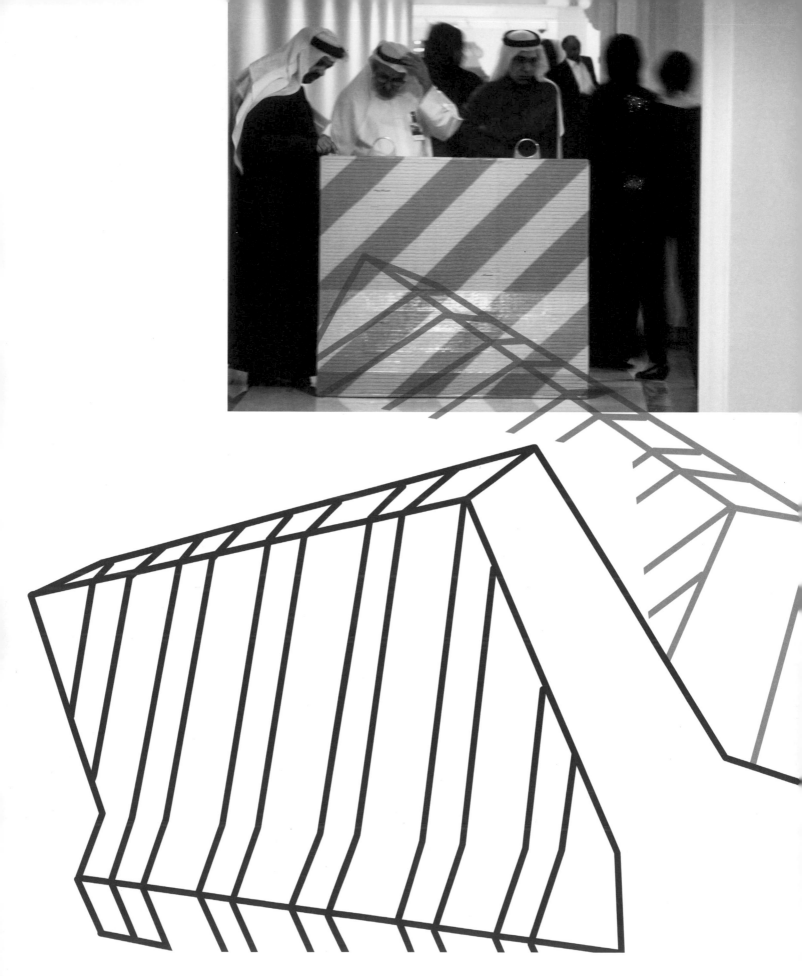

> *Concrete Block* at the Gulf Fine
Arts Society, Sharjah | 2009

that does not have a face. For me, the bomb that falls from the sky, the army that invades your village, the flood, the system of bureaucracy, all of these have this in common. As one man you cannot do anything to stop them. Nor can you see their face. In so much of my work now you see the same thing, and it goes back to the Gulf Wars. Perhaps I feel this more because I am a soldier, I don't know."

Just as it is important to discuss what Gharem's stamp paintings are, we should also touch on what they are not. There is a danger, when approaching these works for the first time, of positioning them within the genre of protest, but none of this work constitutes an attack on the system.

"Always I try to *work with* the system," Gharem insists. "I go *with* the grain. This work contains a positive message."

As Hamza Serafi explains, "Abdulnasser is not out to gain notoriety. Nor is he looking for a cheap thrill. This is important. His work contains a more subtle form of engagement, which is why he continues to make it and why he is so valued in the army. Sometimes you speak to people from outside who imagine that he is a rebel or revolutionary. But what he is doing is more powerful than that. He is trying to bring about change from within, and he is doing that through conversation and an open analysis. When I see what he is doing it reminds me of the story in the Holy Qur'an where God says to Musa and his brother, 'speak to him gently'. For me, this is so important. This is the true spirit of Islam. It also illustrates an element of our culture in Saudi Arabia. If you have a different point of view, you present it to the other person politely and gently. You look to create a dialogue, not a conflict. Abdulnasser understands this."

During the early 21st century the geographic locus of Middle Eastern art began to shift. In the broadest sense, it gravitated away from the Levant towards the Gulf, as evidenced by the efflorescence of new galleries and museums in Doha, Abu Dhabi, Bahrain, Dubai and Sharjah. By 2011 the annual art fair Art Dubai was in its fifth year and had attracted over eighty galleries. In Abu Dhabi, for example, a total of twelve new museums had been announced as part of a stunning £17 billion arts project. The idea was—and remains—for the Gulf to become a major cultural tourist destination, and the effect of all this on the market for contemporary Middle Eastern art has been stimulating, to say the least.

This coincided with a shift in Gharem's artistic fortunes. His art-making career until 2011 can be divided into three stages. It begins with a period of relative obscurity in which his work reaches a limited, local audience. The second stage centres on 2008, Gharem's *annus horribilis*, a year of adverse reactions, criticism and difficulties in his personal life. There follows a third stage in which Gharem enjoys critical recognition and glowing press coverage as he participates in hugely successful exhibitions in London, Venice and Dubai, among others.

By 2009 Gharem was clearly identified as being at the vanguard of a new generation of fashionable young Saudi artists. As such his work was in demand as never before. This presented him with a welcome problem: as a full-time soldier he could not produce enough art. So the year after Edge of Arabia opened

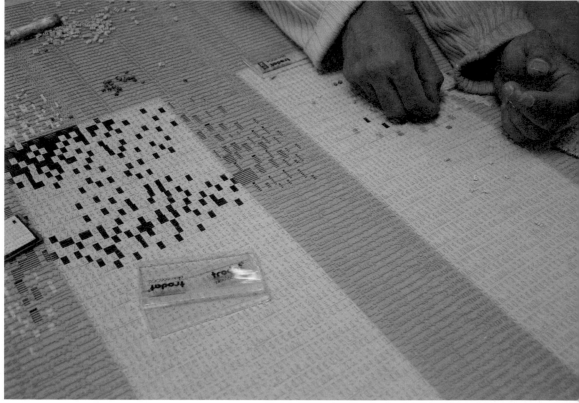

> Rubber stamps in the artist's
studio, Khamis Mushait

in London Gharem set up a nomadic, part-time workshop, the only one of its kind in Saudi Arabia.

It would be run by the seventh of Abdulnasser's siblings, Ajlan, a maths teacher. He is a tall, delicate man who smiles at the world and means it. Since 2009 he has taken his eldest brother's output to a new level. In the space of two years he oversaw with Gharem the creation of more than fifty stamp paintings and concrete barriers, some of which involved more than 90,000 rubber letters.

Setting up an artistic workshop in Saudi Arabia is a feat. Craftsmen with the relevant skills rarely exist. Usually you need to train them up yourself.

"I think contemporary artists in Saudi Arabia face more of a struggle than those elsewhere in the region," says the curator and collector Basma Al-Sulaiman. "There is no infrastructure in place. So our artists must be more resourceful. Most are self-educated. They work hard to find the right materials and the right craftsmen. For me, working like this without an infrastructure explains why Saudi artists today are so inventive."

His desire to set up a workshop points to another aspect of Gharem's character. He works well in a team, especially if he is in charge. This is a man who has spent most of his life at the head of a group, whether his siblings, an army platoon, a workshop, or the team of friends he might work with on artistic projects such as *Siraat*. There are artists like Rirkrit Tiravanija, Antony Gormley or Jeremy Deller, whose work will often involve public participation, but usually this is on a scale that positions the artist above a group of non-artists. They serve as a mute extension of the work.

Gharem's approach is slightly different.

"I believe in letting the others share the artwork with you," he says. "It should be a conversation. Now I make sure to put out designs for my work on the internet before making them. I like to hear the reaction, to respond to it before I make the piece."

Most of these pictures go up on Facebook where they inspire hundreds of comments as different users discuss what the work could mean, should mean - *does* mean, how it could be changed and so on. In 2010 Gharem began to post on Twitter. He developed a website, and soon he was uploading videos of himself discussing his work on television, and related ephemera onto YouTube.

Here Gharem is the prototypical 21st century Saudi Arabian artist. Having begun his career producing neat watercolour paintings in a remote studio, he now runs a team of craftsmen, is a regular face on

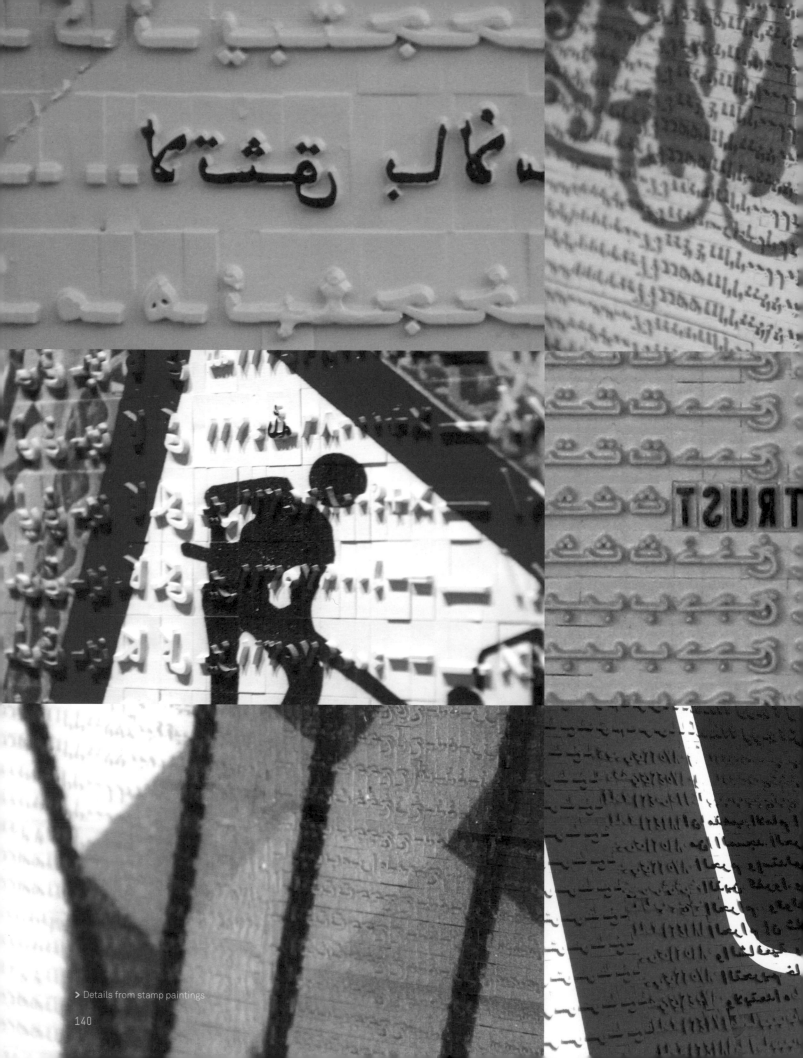

> Details from stamp paintings

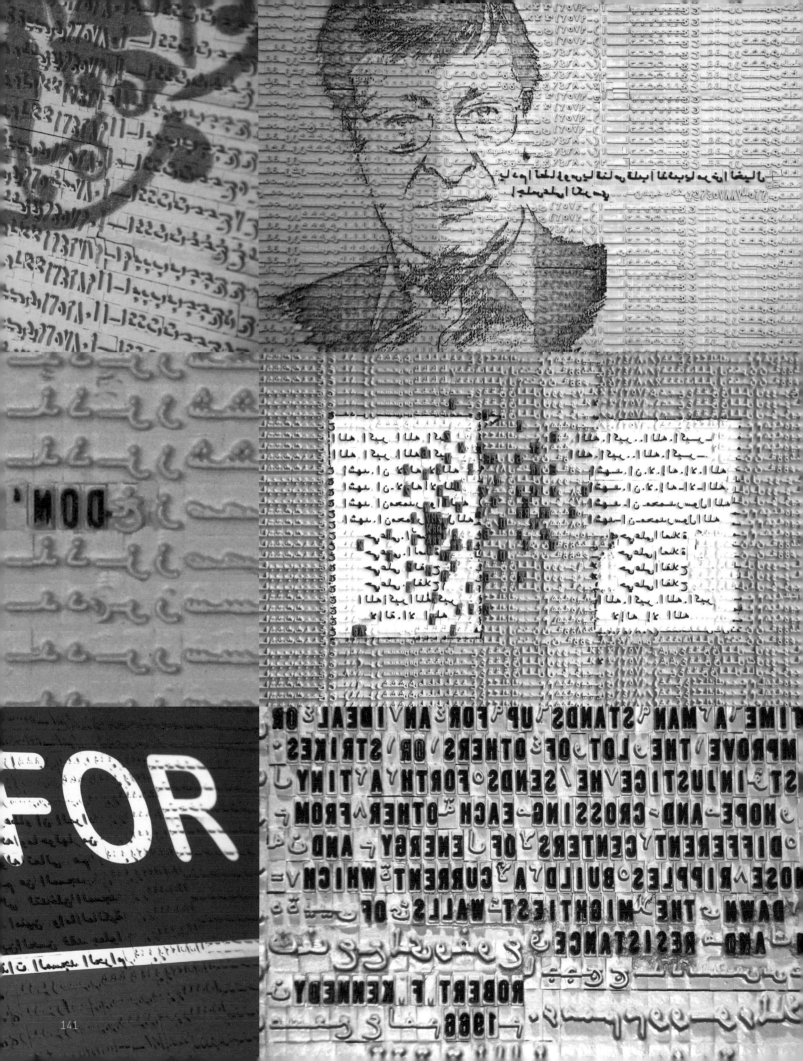

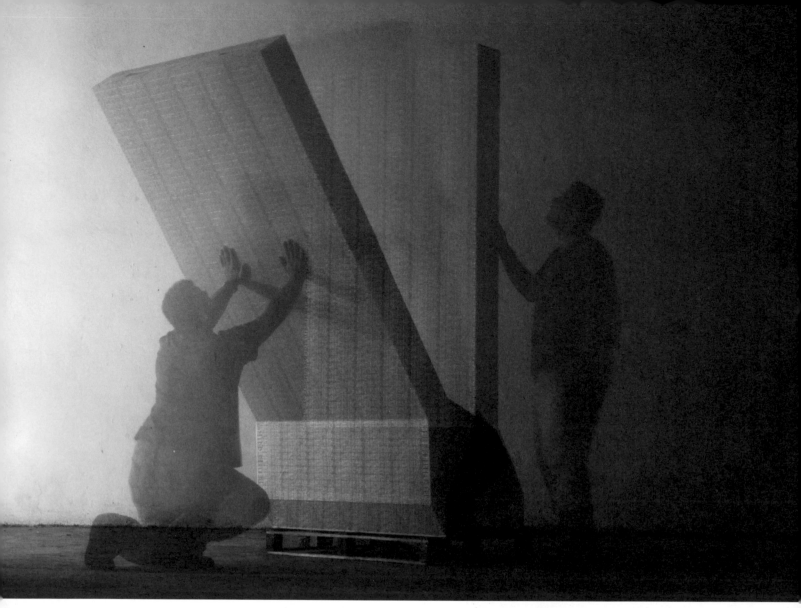

> The artist with *Concrete Block IV* | 2010

Saudi television and has a prolific web presence, using the internet as a forum for testing out new ideas and communicating across international borders.

Saudi art has experienced a similar metamorphosis. When Gharem was growing up it aspired to create a nostalgic reflection of indigenous culture. In the face of epic modernisation this approach could be interpreted as reactionary. Later the prevalent style was more abstract, with a pronounced emphasis on symbolism and realism. During the 21st century, Saudi art has begun to enter a new phase as its practitioners turn to face the future.

Gharem's response to the challenge posed by western contemporary art has not involved a descent into mimesis. Instead he has internalised its methodology and, with time, he has colonised it. The work he produces now is rooted absolutely in its (and his) geographic and social context. This is just one of the reasons why he has no desire to work abroad as so many other successful Middle Eastern artists end up doing.

"The one thing I fear is running out of ideas, and this will happen only if I leave the country, or I stop talking to people. My art is related to people living in Saudi Arabia. I am living in one of the most interesting countries in the world. Why move? I want to show what has happened in this country. My audience is the world but my subject will always be here."

PLATES

PLATES 3

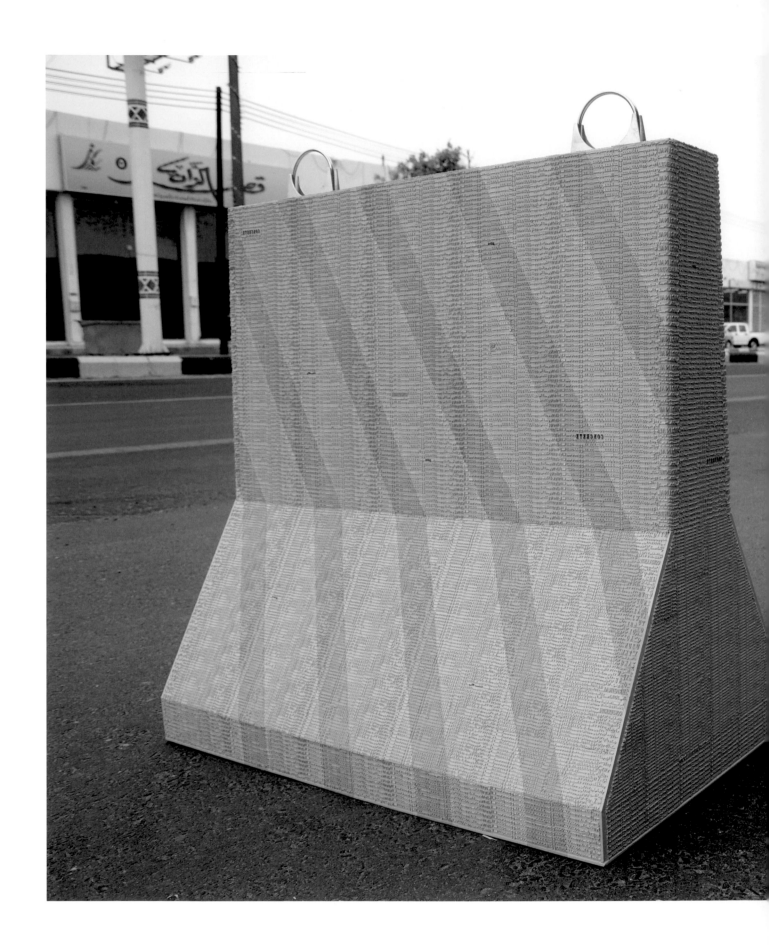

CONCRETE BLOCK
INDUSTRIAL LACQUER PAINT
ON RUBBER STAMPS (ON 0MM
INDONESIAN PLYWOOD STRUCTURE)
H95 x W95 x D50 CM
2009

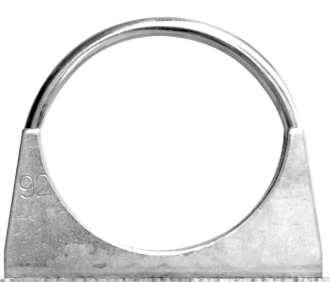

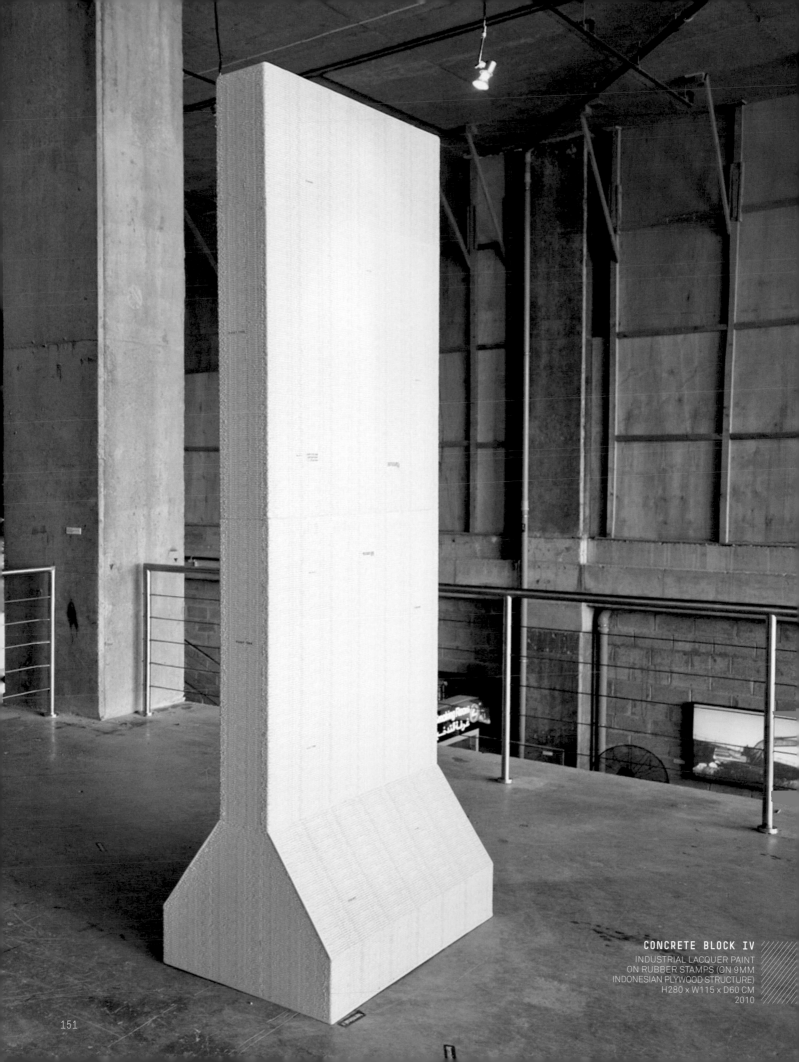

CONCRETE BLOCK IV
INDUSTRIAL LACQUER PAINT
ON RUBBER STAMPS (ON 9MM
INDONESIAN PLYWOOD STRUCTURE)
H280 x W115 x D60 CM
2010

CONCRETE

DON'T TRUST THE CONCRETE

DON'T TRUST

CONCRETE
INDUSTRIAL LACQUER PAINT
ON RUBBER STAMPS (ON 9MM
INDONESIAN PLYWOOD)
H85 x W120 CM
2008

MAHMOUD DARWISH
INK AND INDUSTRIAL LACQUER
PAINT ON RUBBER STAMPS
(ON 9MM INDONESIAN PLYWOOD)
H85 x W120 CM
2009

TANK
INK AND INDUSTRIAL LACQUER
PAINT ON RUBBER STAMPS
(ON 9MM INDONESIAN PLYWOOD)
I185 x W120 CM
2010

MEN AT WORK IV
INK AND INDUSTRIAL LACQUER
PAINT ON RUBBER STAMPS (ON 9MM
INDONESIAN PLYWOOD)
H240 x W300 CM
2010

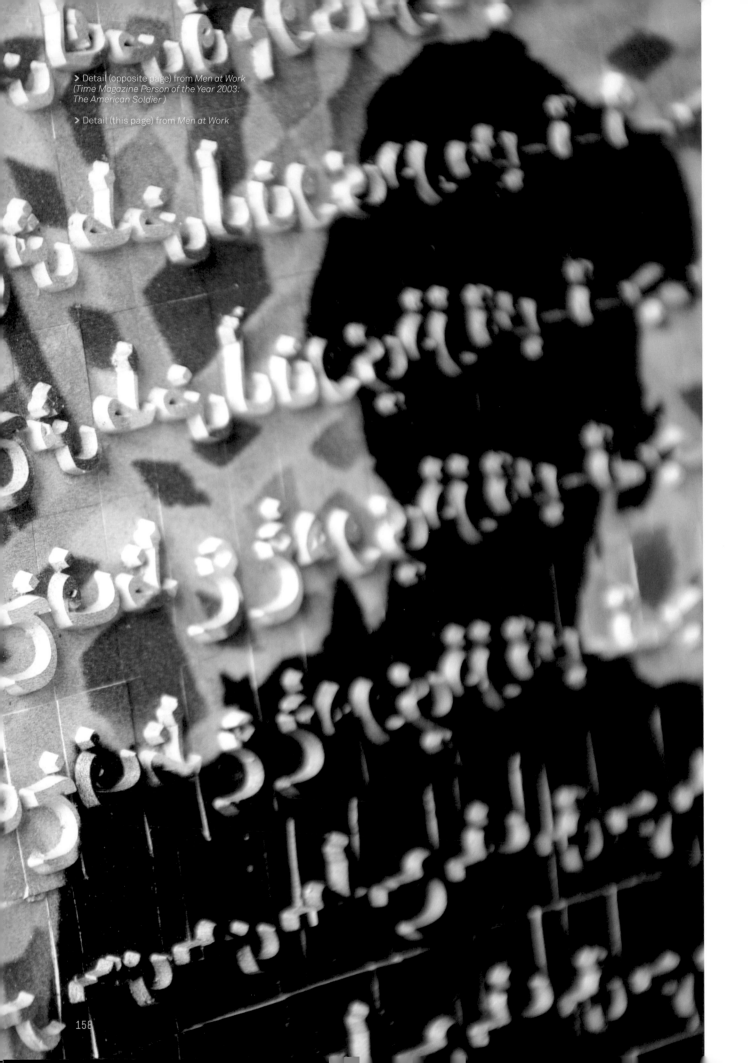

> Detail (opposite page) from *Men at Work*
(*Time Magazine Person of the Year 2003:
The American Soldier*)

> Detail (this page) from *Men at Work*

MEN AT WORK
INK AND INDUSTRIAL LACQUER
PAINT ON RUBBER STAMPS (ON
9MM INDONESIAN PLYWOOD)
H85 x W120 CM
2010

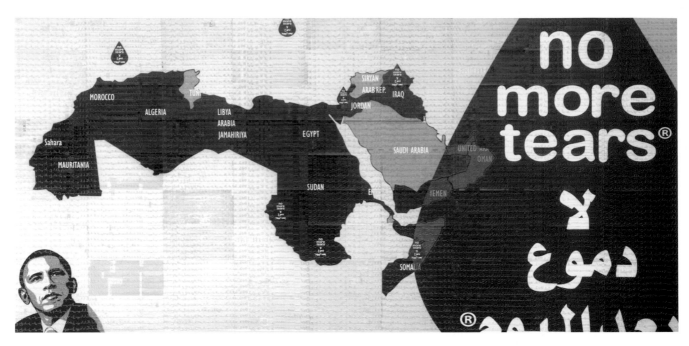

NO MORE TEARS II
INK AND INDUSTRIAL LACQUER
PAINT ON RUBBER STAMPS
(ON 9MM INDONESIAN PLYWOOD)
H115 x W185 CM
2010

NO MORE TEARS VI
INK AND INDUSTRIAL LACQUER
PAINT ON RUBBER STAMPS
(ON 9MM INDONESIAN PLYWOOD)
H115 x W185 CM
2011

NO NATIONS HOLD NUCLEAR WEAPONS

NO BASES

NO SYSTEM OF GOVERNMENT

NO MILITARY BASES

CH CAN ERADICATE YEARS OF MISTRUST

MAKE NO MISTAKE

NOBEL PRIZE

NO MEANS

NO LONGER THREATEN

NO MORE TEARS III
(OBAMA)
INK AND INDUSTRIAL LACQUER
PAINT ON RUBBER STAMPS
(ON 9MM INDONESIAN PLYWOOD)
H115 x W185 CM
2010

NO MORE TEARS IV (OBAMA:
NO OR BAD SIGNAL)

INK AND INDUSTRIAL LACQUER
PAINT ON RUBBER STAMPS (ON 9MM
INDONESIAN PLYWOOD)
H160 x W200 CM
2010

NO MORE TEARS V (OBAMA:
NO OR BAD SIGNAL)

INK AND INDUSTRIAL LACQUER
PAINT ON RUBBER STAMPS (ON 9MM
INDONESIAN PLYWOOD)
H160 x W200 CM
2010

PAUSE [DIPTYCH]
INK AND INDUSTRIAL LACQUER
PAINT ON RUBBER STAMPS
(ON 0MM INDONESIAN PLYWOOD)
H115 x W185 CM x 2
2011

ROAD TO MAKKAH
INK AND INDUSTRIAL LACQUER
PAINT ON RUBBER STAMPS (ON 9MM
INDONESIAN PLYWOOD)
H70 x W330 CM
2011

IN TRANSIT
INK AND INDUSTRIAL LACQUER
PAINT ON RUBBER STAMPS
(ON 9MM INDONESIAN PLYWOOD)
H160 x W200 CM
2010

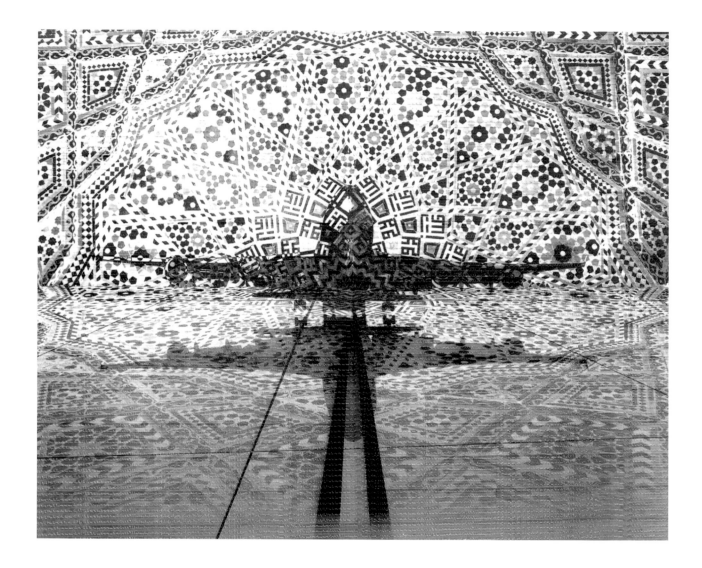

IN TRANSIT II
INK AND INDUSTRIAL LACQUER
PAINT ON RUBBER STAMPS
(ON 9MM INDONESIAN PLYWOOD)
H160 x W200 CM
2010

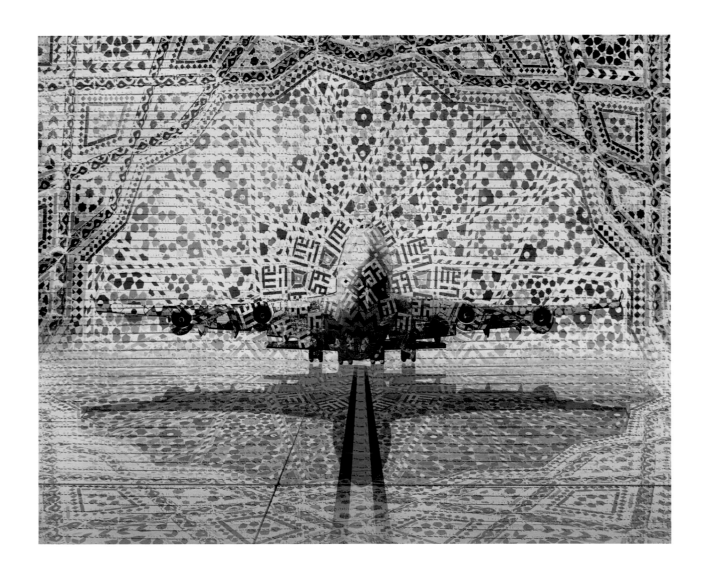

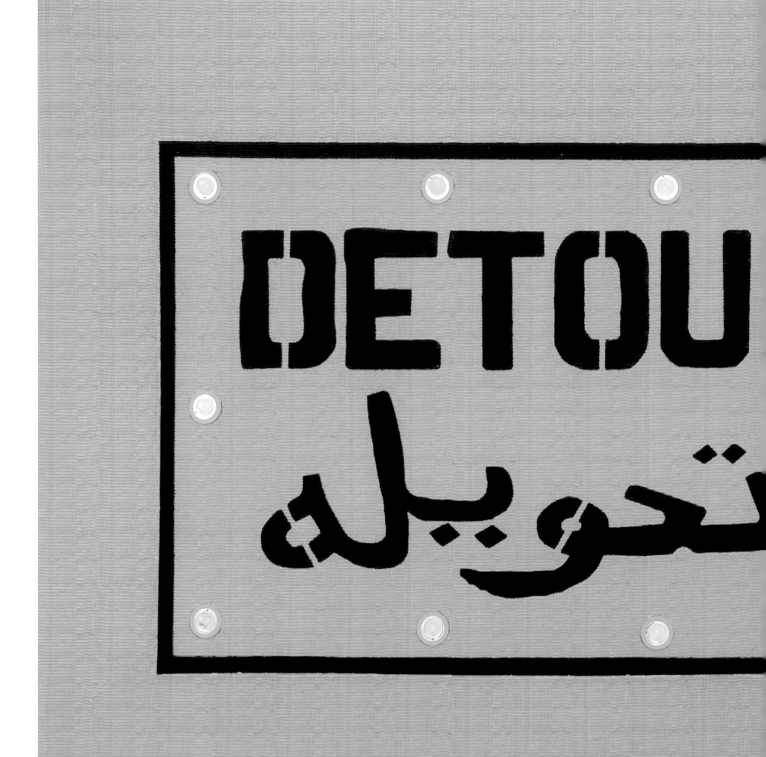

DETOUR
INK AND INDUSTRIAL LACQUER
PAINT ON RUBBER STAMPS
WITH 10 LIGHTS (ON 9MM
INDONESIAN PLYWOOD)
H150 x W240 CM
2009

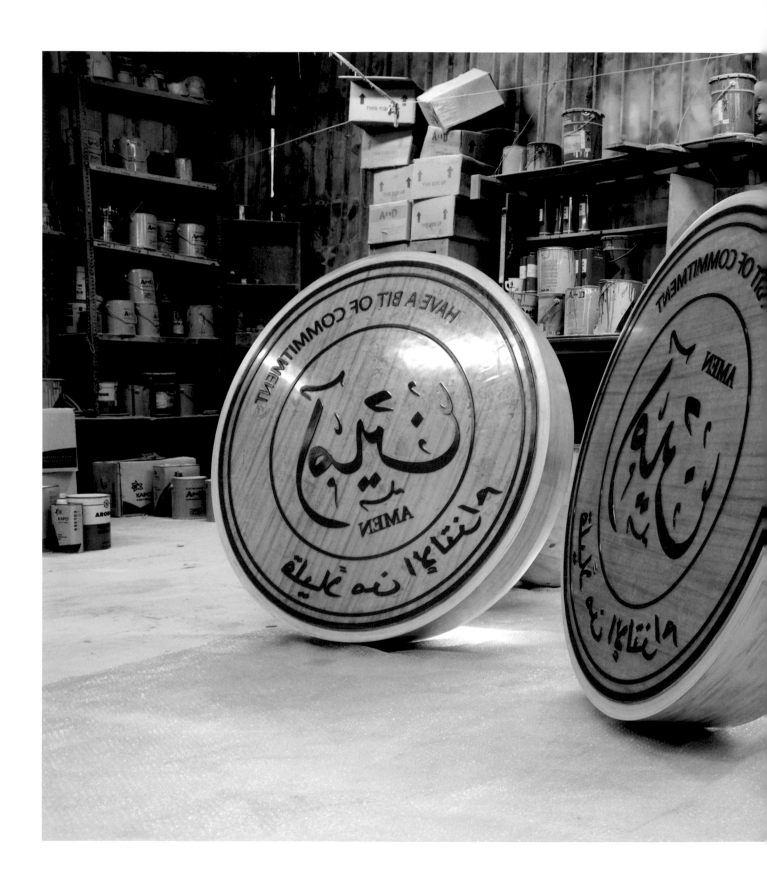

THE STAMP (AMEN)
II & III
RUBBER ON OVERSIZED
WOODEN STAMP
H95 x W95 x D50 CM
2010

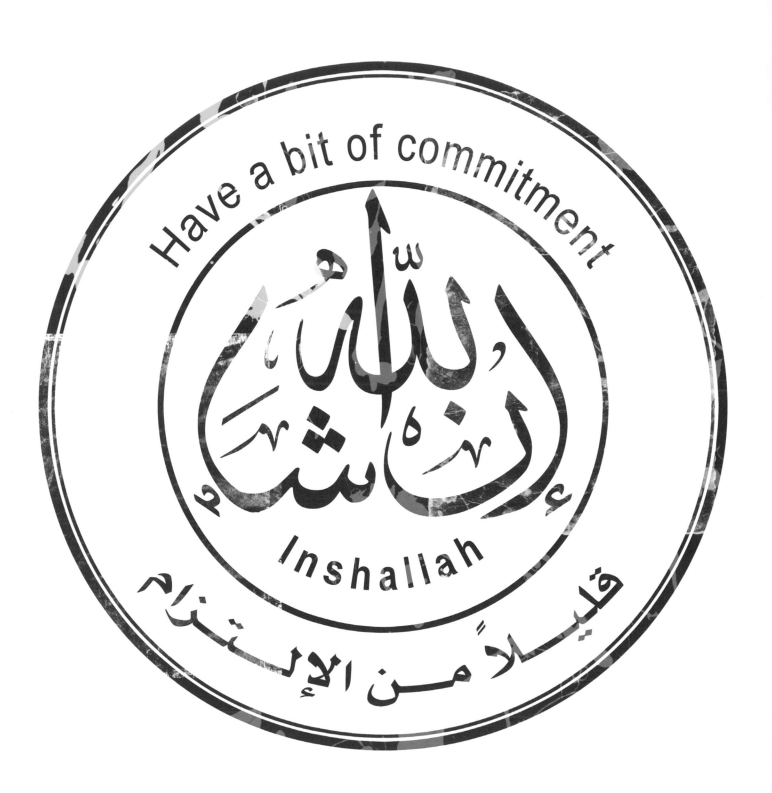

TRIBE

Less than a year before that balmy evening in Dubai in 2011, when Message/Messenger went under the hammer, Abdulnasser bin Gharem bin Ajlan Al-Ajlan Al-Amri, a man described in Rolling Stone magazine as the "rock star" of Saudi art, returned to the sleepy village of Sadra-Eyt where he had grown up. He was there to stage an exhibition of his work. There had never before been an art exhibition in Sadra-Eyt...

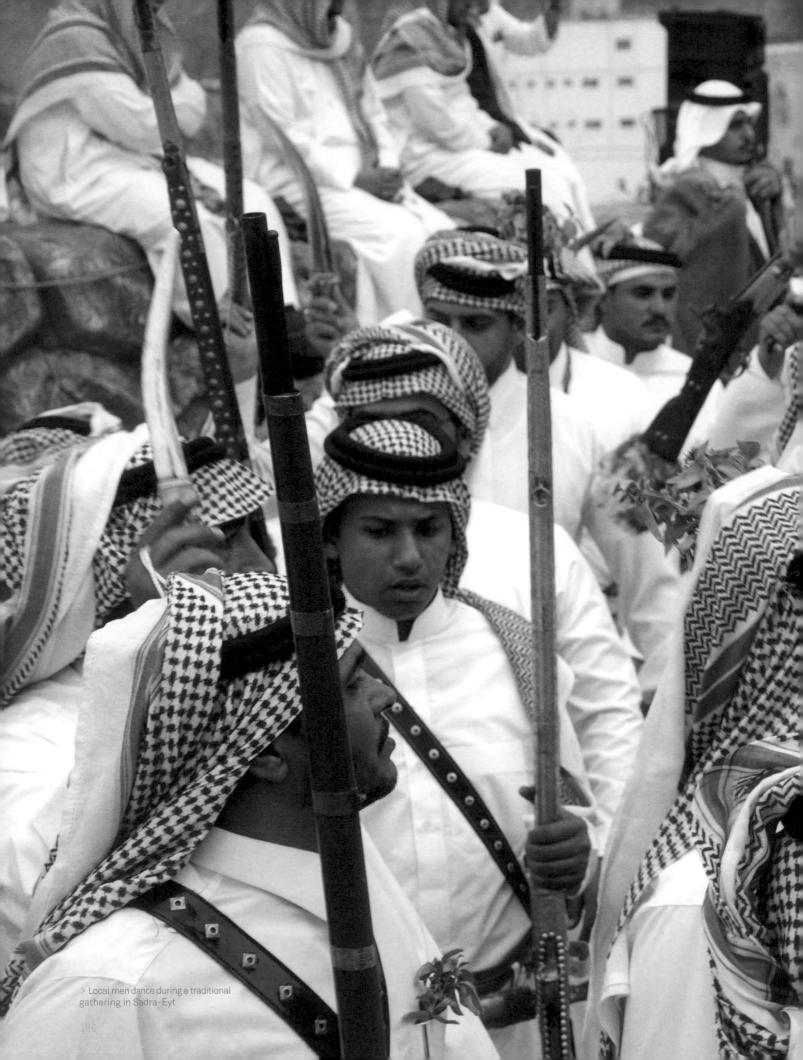

Local men dance during a traditional gathering in Sadra-Eyt

180

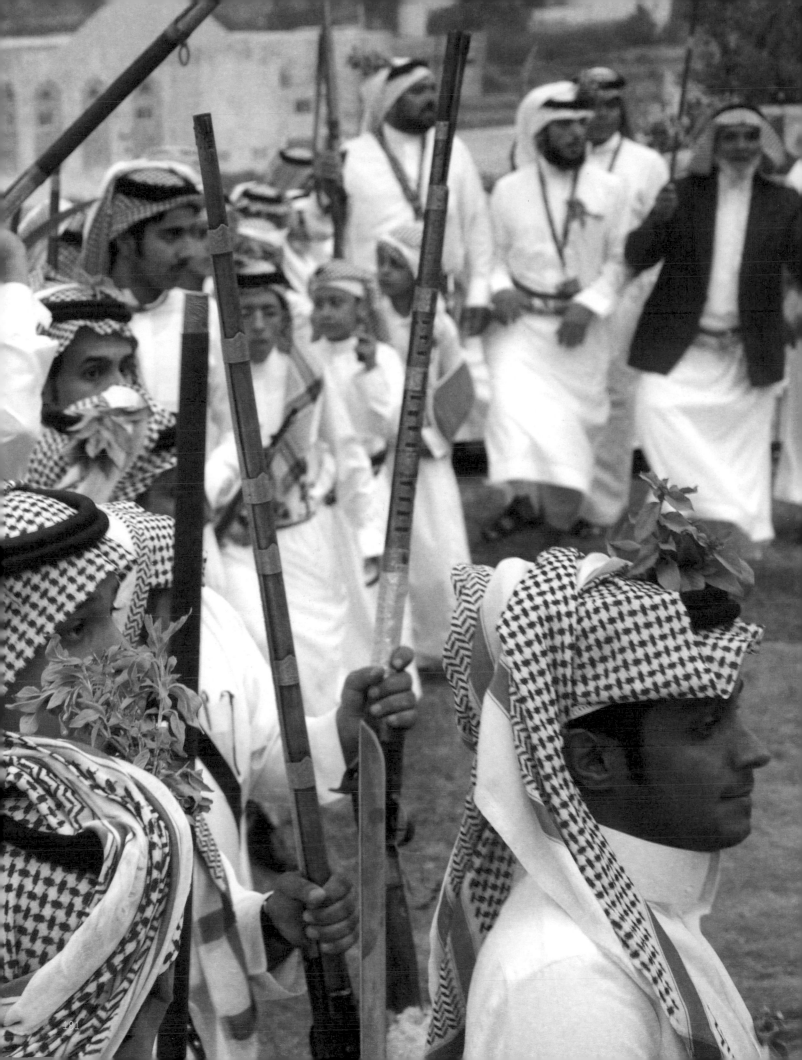

> The artist's father at home | 2011

THIS IS WHERE GHAREM GREW UP, WHERE HE LEARNT TO WALK AND TALK, WHERE HE PLAYED, GOT LOST AND WATCHED HIS GRANDFATHER, THE LOCAL SHEIKH, HOST A REGULAR MAJLIS

The landscape around this village is a world away from the Saudi Arabia of dunes, tents and bleached-out desert landscapes. Sadra-Eyt is lodged high on a fertile, terraced plateau in the Sarawat mountains. It feels removed from the land of oil, *Mutawa* and the unending ping of mobile phones. If nothing else, with regular lightning strikes up here, it is not always wise to venture out with your phone switched on.

This is where Gharem grew up, where he learnt to walk and talk, where he played, got lost and watched his grandfather, the local sheikh, host a regular *majlis*. His childhood was spent at his grandparents' house, a long, whitewashed block on the edge of a clump of similar-sized basalt buildings. The walls here can be more than a metre deep. At the heart of the village is an ancient mosque, probably the oldest in this part of the peninsula. The streets are made of bare earth and they smell of damp goat hair. Beyond you see a rare sight in 21st century Saudi Arabia: women working the fields.

For a reminder of what life was like around here until recently you need look no further than the doors of these medieval homes. They are barriers as much as gateways, each one designed to withstand sustained attack from rival tribes. They are covered in decorations made long ago by a man thought to have looked just like Abdulnasser.

For the exhibition in Sadra-Eyt Gharem pulled no punches. In a low-ceilinged, stuccoed room he hung *Manzoa*, *Flora & Fauna*, a stamp painting of Mahmoud Darwish, several paintings made long ago in Al-Meftaha, and at the heart of the room he placed a photograph of *Siraat*.

This miniature exhibition just a few yards from what had been his childhood bedroom offers a neat précis of the artistic journey he has made. If nothing else, it is a reminder of the international and local sensibilities that combine within his work. Other editions of the pieces hung in this mountainous village belong to collections in the British Museum and the Los Angeles County Museum of Art. As the collector Rüdiger Weng puts it, "what has always set Lt. Col. Gharem apart is his status as a kind of 'outsider' within the art scene of the Middle East, a conceptual artist dealing with purely local issues." Dr Al-Sebail, the Deputy Minister of Culture, echoes this. "His local knowledge is very good. When you see a piece like *Siraat* you understand that he is really attached to the local culture. You know where he is coming from. Yet I think his work relates to all people. Though it has a local flavour the concept is international."

This was the first time *Siraat* had been shown in public anywhere in Saudi Arabia. As before, the parameters of acceptable visual culture were in flux. Here was confirmation of that shift.

"Nowadays in Jeddah when we open our exhibitions we do not need to ask for the same permissions as before," says the gallerist Hamza Serafi. "There is more trust in the artists. The different ministries are more open to positive criticism. Everywhere there is more debate."

Just as the bounds of what you can show have changed, the idea of being a contemporary artist in Saudi Arabia has acquired a new credibility. For many years Gharem did not reveal to his troops that in his spare time he made art. It did not feel right. It might undermine his authority, and perhaps the soldiers would not understand. As Gharem knew from growing up in Sadra-Eyt, and later Khamis Mushait, in Saudi Arabia it is important to have one face you present to the community and another for yourself.

"Often I would drive past the site of *Siraat* with these soldiers," he says. "I'd point at the bridge and ask them about it. They all knew this story and would talk about it. But there is no way I would tell them about *Siraat*. Not then."

By 2010 this had changed. The idea of a respectable Saudi national spray-painting the word *siraat* several thousand times over the ruined remains of a bridge was less outré than it had been in 2003. By then Gharem had told his soldiers that he was an artist, to which they responded well. He began to hear about other soldiers who also made art in their spare time. So many, in fact, that he organised an exhibition of art made by the soldiers in his unit. His commander liked the show so much that he asked Gharem to curate in Riyadh a national exhibition of art and design by members of the entire Saudi Arabian Land Forces.

In Saudi Arabia today there is a new understanding of what an artist can or should be. With Gharem at the fore, a generation of artists including Ayman Yossri, Manal Al-Dowayan, Raja & Shadia Alem and Ahmed Mater, Gharem's former collaborator in the Shattah collective, is engaging openly and creatively with their social and political environment. Equally important is the next generation of artists.

"Artistically, Abdulnasser has been very generous to me," says the young Saudi artist Hala Ali. "He's given me advice and introduced my work to many people. He often talks about passing on the baton to me and my generation. Of course everyone in my generation knows about him as one of the pioneers, somebody who has taken great risks, especially with his performances. But it's good to see just how much he wants others to succeed. As he always says to me, 'I've planted the seed. Now it's time for you and others to let it bear fruit.'"

Ali's contemporary Sami Al-Turki echoes this sense of Gharem as a mentor figure.

"When I heard the story of what he did back in 2008 in London with the first stamp painting, the one that he added a third stripe to, I was so impressed," says Al-Turki. "I think this story is extremely important. It says a lot about censorship, and I admire Abdulnasser's response to the situation hugely."

With Gharem leading the way, the role of the Saudi contemporary artist has grown more complex, and more nuanced. In his essay, "On Commitment," Theodor Adorno wrote that "works of art, even literary ones, point to the practice from which they abstain: the creation of a just life."

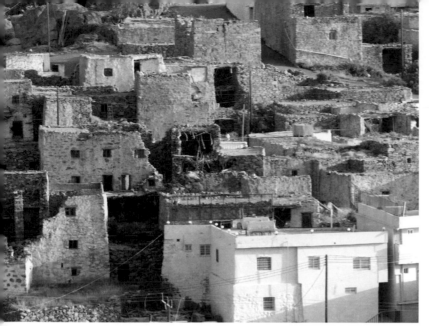

This is particularly true in Saudi Arabia today. As the curator Robert Kluijver explains, "the lack of an established contemporary Saudi art scene has placed added emphasis on journalism and social commentary for these artists. Sure, for some people this goes against the western ideal of art for art's sake *(l'art pour l'art)*: the autonomous artist who cannot be bothered by worldly affairs and is set apart from society. But this is precisely what adds such a fresh dimension to Saudi art. These artists end up somewhere between the journalist and the poet. This is a powerful position to occupy."

It can be much too easy to state that an artist 'engages with social and political issues', simply because these are referenced in their work. Only a minority of artists will do this in a meaningful way. Gharem does not just communicate with gallery-goers, he *engages* in the fullest sense of the word. For example, he gives presentations at the American Embassy in Riyadh about his work and has become a regular commentator on Saudi national television where he discusses the issues raised by his art.

"He's a great communicator," confirms Fady Jameel. "There is something forceful about the way he speaks. It's inspiring. It makes you listen."

Nationwide he has something of a following. This is partly thanks to the moment in 2011 when he was asked live on prime time Saudi television by a female presenter why it was that he made art, given his lack of formal training.

"Have you ever been in love?" Gharem asked her.

"Yes," she said, a little nervously.

"How can you do this without any formal training?"

Here is someone who has learnt to recognise contingency and—crucially—to fashion it to his advantage. He moves among the people he has grown up around, remixing social situations in order to question them playfully.

"Abdulnasser is one of the most courageous artists I know," says Mohammed Hafiz, co-director of Jeddah's Athr Gallery. "*Message/Messenger*, for example, was a huge financial risk. It cost him a lot to produce and he had to spend money he did not have. But this is the way with him. When he sets out to do something it must be right, and he does not mind taking big risks."

He does this without being a member of any self-professed art scene. Ask him about his influences and rather than list a string of contemporary artists, he'll tell you about what he's been reading that week. Last time I asked it was Thomas More, Ibn Khaldun and Jean Piaget. Before that, Milan Kundera, Gabriel Garcia Marquez, the philosopher Francis Bacon and Joseph Beuys, who is, admittedly, more of an artist than a writer, but nonetheless a figure Gharem admires – partly because he too was in the military.

What made the event of Gharem's exhibition in Sadra-Fyt even more compelling, apart from the work on show, was how many people turned up.

"We had many members of our family who flew in for this from Kuwait, from Yemen and from the Gulf," explains Gharem's father, now a sheikh like his father before him. "There were two hundred people from our tribe who came. So it was a very proud occasion for me. Abdulnasser made a great exhibition."

IN SAUDI ARABIA
TODAY THERE IS A NEW
UNDERSTANDING OF WHAT
AN ARTIST CAN OR
SHOULD BE

The opening ceremony provided a powerful juxtaposition. In one room was a series of artworks that had once been portrayed as an arsenal of cultural provocation. The most 'explosive' of them all, *Siraat*, was so prominent that you could see it from outside the room.

Once the exhibition had formally opened, Gharem gave a speech before the action moved away from the tiny gallery to the courtyard outside. By now the sky was mud-dark. Drums started up, a poet began to sing and as the men chanted up into the sky, they danced. The valley was flooded with sound. The men held swords and guns above their heads as they performed the dance of their forefathers before they would go into battle. It was a traditional dance that Gharem knew well from his days at the military academy. Through it all went Lieutenant-Colonel Abdulnasser Gharem, insider and outsider, a once-in-a-generation phenom who had returned to the house where he had grown up to describe the journey he had made.

The day fell away until it was time to pray. Later that night they sat down to plates piled high with food. There was lamb that had been slaughtered for the occasion accompanied by honey and fruit from the farm. The mood turned to talk, and late into the night Gharem discussed his artistic journey. He described the decisions he had taken. He told them about the path he had chosen. *Mashallah*, it was the right path.

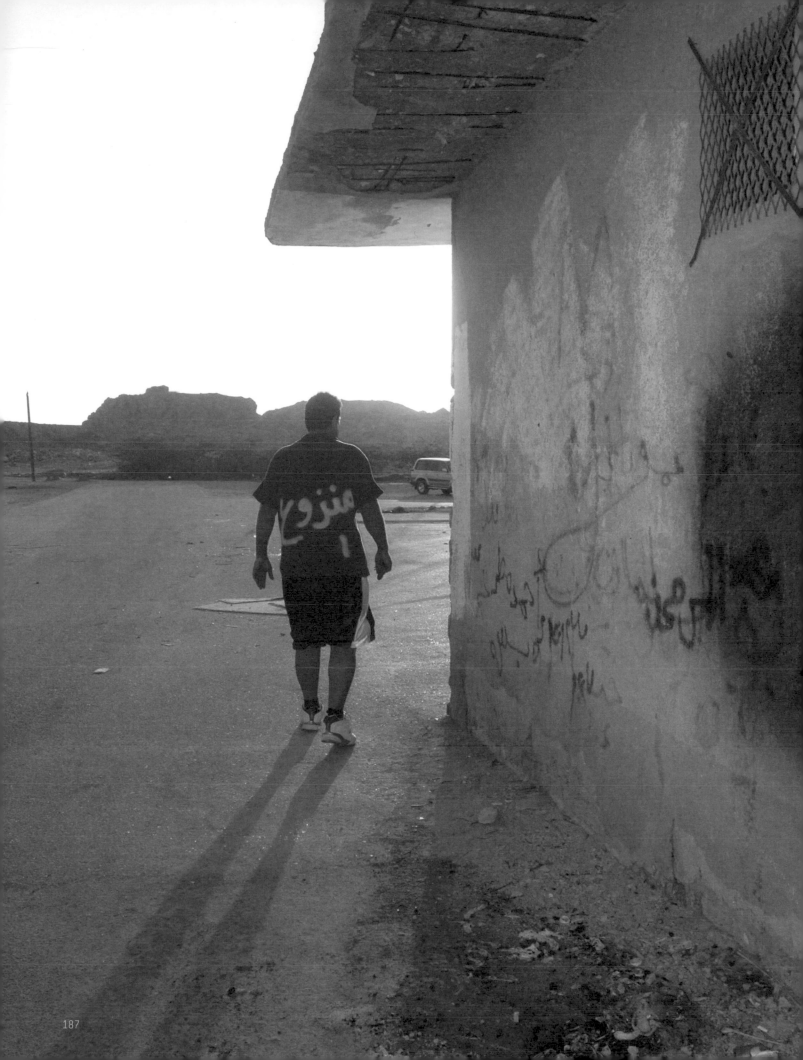

ENDNOTES

[1] Ali Khadra. "Art Renaissance in the Middle East,"
Raconteur on Art in the Middle East.
The Times, 17 March 2011

[2] Sheikha Mai. "Art's 21st Century Grand Tour,"
Raconteur on Art in the Middle East.
The Times, 17 March 2011

[3] Sharon Waxman. "An Oasis in the Desert."
ARTnews, February 2009

[4] George Orwell. "Why I Write." Gangrel, 1946

[5] Lewis Hyde. *Trickster Makes This World*.
Canongate, 2008

[6] Ana Finel Honigman. Alef, Winter 2007

[7] Robin Simcox. *A Degree of Influence: the funding of
strategically important subjects in UK universities.*
Centre for Social Cohesion (London), 2009

[8] Robert Lacey. *Inside the Kingdom*. Arrow, 2009

ACKNOWLEDGEMENTS

The production of this monograph has been a truly collaborative effort. Of the many people who helped, we would like to start by thanking Abdulnasser's wife, Abeer, and his family, in particular his brothers Ajlan and Wael, his daughters Yara and Jaadi, his mother Aziza and his father Gharem bin Ajlan Al-Ajlan Al-Amri.

This book would not exist without the generosity and intellectual faith of its patrons. In particular, the guidance and support of Fady Jameel has helped Gharem reach an international audience. We also owe a huge debt of gratitude to Abdullah Al-Turki, Rami Farook, Mohammed Hafiz and Hamza Serafi.

For his wisdom and encouragement at the beginning of Gharem's career we would like to thank Prince Khalid Al-Faisal, the then Governor of Aseer, and Prince Faisal bin Salman, whose support of contemporary Saudi artists is much appreciated. Abdulaziz Al Sebail, Basma Al-Sulaiman, Rudy Weng, Sheikh Sultan Al Qassami, Dr Farhad Farjam, Lina Lazaar, Saeb Eigner, Venetia Porter, Robert Kluijver, Aarnout Helb and Sarah Al-Faour have been loyal supporters along the way.

We are enormously grateful to Edward and Julia Booth-Clibborn for their wise counsel on the production and editing of this book, and their enthusiasm in supporting a new generation of Saudi artists.

At Edge of Arabia, this book would not have happened without the imagination and relentless drive of Miriam Lloyd-Evans. As assistant editor she has shown great commitment, professionalism and a strong editorial flare.

The production and promotion of Gharem's work owe a great deal to both Miriam and Aya Mousawi, the latter of whom has worked passionately alongside Gharem since 2008.

We would like to thank Rob Heavey and Róisín McAvinney at One Darnley Road for their consistently excellent design, and Ananda Pellerin for her skilful copy-editing.

To find out what Abdulnasser is working on now, please visit **www.abdulnassergharem.com**.

Abdulnasser Gharem, Henry Hemming, & Stephen Stapleton.

All photographs courtesy of Abdulnasser Gharem apart from:

Page 8-9, 22, 58-59, 116, 123, 150-151: courtesy of Edge of Arabia.

Page 37, 49: courtesy of Stephen Stapleton.

Page 182: courtesy of Henry Hemming.

CHRONOLOGY

1973 | Abdulnasser bin Gharem bin Ajlan Al-Ajlan Al-Amri is born in Khamis Mushait in the mountainous Aseer region of southern Saudi Arabia. His family originates from Sadra-Eyt.

1989 | Enrols at Abu Bakr Saddique Secondary School, Khamis Mushait.

1990-91 | Invasion of Kuwait by Iraq leads to the first Gulf War.

1991 | Invited to work at the Al-Meftaha Arts Village in Abha, under the patronage of the then Governor of Aseer, HRH Prince Khalid Al-Faisal.

1991 | Awarded the Kuwaiti Freedom Prize for an early watercolour landscape.

1992 | Enrols at King Abdulaziz Military Academy, Riyadh.

1995 | Graduates from military academy. Joins the Saudi Arabian Army as 2nd Lieutenant Gharem.

1997 | Promoted to 1st Lieutenant Gharem.

2001 | Promoted to Captain Gharem.

2003 | Invasion of Iraq by Allied forces leads to the second Gulf War.

2003 | Performance of *Siraat (The Path)* in the Tihama Valley.

2004 | Organises and takes part in Shattah exhibition at the Atelier Gallery in Jeddah.

2006 | Invited to become co-founder of the Edge of Arabia project with Stephen Stapleton and Ahmed Mater.

2007 | Shows *Flora & Fauna* at the 8th Sharjah Biennial.

2007 | Promoted to Major Gharem.

2008 | Shows first stamp paintings at the inaugural Edge of Arabia exhibition in London.

2009 | First public display of *Siraat (The Path)* during the 53rd Venice Biennale. The work is consequently collected by the Victoria and Albert Museum, and the Los Angeles County Museum of Art.

2010 | Inclusion in *Taswir: Pictorial Mappings of Islam and Modernity*, at the Martin Gropius-Bau Museum, Berlin.

2010 | *The Art Newspaper* commissions a feature about Gharem entitled "What is the Difference between an Artist and a Soldier?"

2011 | Promoted to Lieutenant-Colonel.

2011 | Sale of *Message/Messenger* at Christie's Dubai breaks world record, establishing Gharem as the highest selling Gulf artist alive.

2011 | *Rolling Stone Middle East* publishes a feature entitled "Abdulnasser Gharem and the Art of War" which begins with the statement: "There aren't many artists who are trained to kill."

2012 | Inclusion of *Road to Makkah* in *Hajj, Journey to the Heart of Islam*, at the British Museum, London.

COLLECTIONS & EXHIBITIONS

COLLECTIONS:

The British Museum
The Victoria and Albert Museum
Los Angeles County Museum of Art
The Saudi Arabian Ministry of Culture and Information
The Jameel Foundation
Nadour Collection
Greenbox Museum
The Barjeel Art Foundation
The Farook Collection
The Farjam Collection
Kamel Lazaar Foundation
BASMOCA: Basma Alsulaiman Museum of
Contemporary Art

SELECTED EXHIBITIONS:

2012 | Hajj, Journey to the Heart of Islam – British Museum, London (26 Jan-15 Apr)

2012 | Edge of Arabia, Jeddah (Jan)

2011 | Political Patterns – ifa-Galerie, Berlin (8 Jul-3 Oct)

2011 | The Future of a Promise: Contemporary Art from the Arab World – Magazzini del Sale, 54th Venice Biennale (1 Jun-27 Nov)

2011 | The Bravery of Being Out of Range – Athr Gallery, Jeddah (24 May-18 Jun)

2011 | The New Middle East – Willem Baars Projects, Amsterdam (31 May-30 July)

2011 | Edge of Arabia Dubai: TERMINAL – Building 9, Gate Village, Dubai International Financial Centre (14 Mar-15 Apr)

2011 | Uppers & Downers – Traffic, Dubai (9 Feb-5 Mar)

2011 | Nujoom: Constellations of Arab Art from The Farjam Collection – The Farjam Collection @ DIFC, Dubai (1 Nov ((2010)) - Mar 2011)

2011 | I Don't Need Your Money Honey All I Need is Love – Traffic, Dubai (5 Jan –27 Jan)

2010 | Edge of Arabia Istanbul: TRANSiTION – Sanat Limani, Antrepo 5 (10 Nov-10 Dec)

2010 | Opening the Doors: Collecting Middle Eastern Art – Emirates Palace, Abu Dhabi Art, Abu Dhabi (3 Nov-7 Nov)

2010 | CAVE: Contemporary Arab Video Encounter – Maraya Arts Centre, Sharjah (2 Nov-11 Dec)

2010 | Emerging Asian Artists, Gwangju Biennale (1 Sep-5 Sep)

2010 | Edge of Arabia Berlin: Grey Borders/Grey Frontiers – Soho House, Berlin (9 Jun-18 Jul)

2010 | Fuck Ups, Fables and Fiascos – Galerie Caprice Horn, Berlin (8 Jun-17 Sep)

2010 | Restored Behaviour – XVA Gallery, Dubai (16 Jan-10 Mar)

2010 | Edge of Arabia World Tour Launch – Global Competitiveness Forum, Riyadh (23 Jan-26 Jan)

2010 | Taswir: Pictorial Mappings of Islam and Modernity – Martin Gropius-Bau, Berlin (5 Nov ((2009)) -18 Jan)

2009 | The 28th Annual Exhibition – Gulf Fine Arts Society, Sharjah (March)

2009 | Edge of Arabia Venice – Palazzo Polignac, 53rd Venice Biennale (5 Jun-2 Aug)

2008 | Edge of Arabia London: Contemporary Art from Saudi Arabia – SOAS Brunei Gallery, University of London (16 Oct-13 Dec)

2007 | Still Life: Art, Ecology and the Politics of Change, Sharjah Biennial 8 (4 Apr-4 Jun)

2006 | Son of Aseer – Al-Meftaha Arts Village, Abha (10 Oct-30 Oct)

2006 | Siraat (The Path) – King Fahd Art Village, Abha

2004 | The White Tongue Who Speaks Slowly – King Fahad Art Village, Abha

2004 | Who Keeps Watching the Sun (Sunflower field), Death Mattered – Atelier Gallery, Jeddah

2004 | Shattah – Atelier Gallery, Jeddah (27 Apr -14 May)

BIBLIOGRAPHY

Selected cited publications and articles as
well as general works and resources exploring
the life and work of Abdulnasser Gharem

BOOKS & CATALOGUES:

Abu Dhabi Art. *Opening the Doors: Collecting Middle Eastern Art*.
Tourism Development & Investment Company: 2010.

Amirsadeghi, Hossein and Maryam Homayoun Eisler, eds.
Art & Patronage: The Middle East. Thames & Hudson: 2010.

Booth-Clibborn, Edward and Stephen Stapleton, eds. *Edge of
Arabia: Contemporary Art from the Kingdom of Saudi Arabia*.
Booth-Clibborn Editions: 2011.

Çoruh, Almut Sh. Bruckstein and Hendrik Budde, eds. *Taswir:
Pictorial Mappings of Islam and Modernity*. Nicolaische
Verlagsbuchhandlung Gmbh: 2009.

Downey, Anthony and Lina Lazaar, eds. *The Future of a Promise:
Contemporary Art from the Arab World*. Ibraaz Publishing: 2011.

Eigner, Saeb. *Art of the Middle East: Modern and Contemporary
Art of the Arab World and Iran*. Merrell Publishers Ltd: 2010.

Eltorie, Aida, ed. *Cave: Contemporary Arab Video Encounter*.
Maraya Arts Centre: 2010.

Farjam, Farhad, ed. *Nujoom: Constellations of Arab Art from
the Farjam Collection*. The Farjam Collection: 2011

Issa, Rose and Michket Krifa, eds. *Arab Photography Now*.
Kehrer Publisher: 2011.

Lee, Yongwoo, ed. *Emerging Asian Artists*. Gwangju Biennale
Press: 2010.

Persekian, Jack. *Still Life: Art, Ecology and the Politics of Change*.
Sharjah Biennial: 2007.

Vogel, Sabine B., Ev Fischer and Barbara Barsch, eds.
Political Patterns. ifa-Galerie Berlin: 2011.

PRINT & ONLINE ARTICLES:

Al-Angary, Mazen, ed. "The Survival Gene of the Award Winning
Abdulnasser Gharem." *What's Up Jeddah* Sept-Oct 2008: 38-41.

Adams, Tim. "The Rembrandt of Riyadh." *New York Times*
30 Jan 2011: 28.

Grundey, Adam. "Abdulnasser Gharem and the Art of War."
Rolling Stone Middle East, Mar 2011: 25.

Hemming, Henry. "What's the difference between a soldier and
an artist?" *The Art Newspaper* Feb 2010: 32.

Hemming, Henry. "Abdulnasser Gharem: Profile." *Canvas Magazine*
Nov/Dec 2011.

Hemming, Henry. "Abdulnasser Gharem." *Nafas Art Magazine* Nov
2008. http://universes-in-universe.org/eng/nafas/articles/2008/
abdulnasser_gharem

Honigman, Ana Finel. "The Art of Survival." *Alef Magazine* winter
2007/2008: 130-132.

Khan, Somaiya. "Edge of Arabia: Saudi Art in Focus."
Emel Magazine Dec 2008: 24-35.

Lawrence, Jeremy. "Artists from the Edge: Abdulnasser Gharem."
Esquire Mar 2011: 83.

Mayer, Henry. "Saudi artists set for boom as King supports drive to
go global." *Bloomberg Online*. Bloomberg L.P., 3 May 2010. http://
www.bloomberg.com/news/2010-05-02/saudi-artists-see-prices-
surge-as-king-backs-exhibition-drive-to-go-global.html

Mattar, Dalia. "Don't put your trust in the Concrete."
Arab News Nov 2010.

Mishkhas, Abeer. "Saudi Arabian Artists to Auction Works at
Christie's Dubai to Fund Education Programme." *Asharq Al-Awsat*
16 February 2011: 17.

Mohammad, Arsalan. "Outside the Kingdom." *Brownbook*
Jul - Aug 2010: 78-84.

Moon, Timur. "Command Structure." *The National* 18 Nov 2010: 4.

ONLINE RESOURCES:

Abdulnasser Gharem's official website:
www.abdulnassergharem.com

Edge of Arabia: www.edgeofarabia.com

Greenbox Museum: www.greenboxmuseum.com

Nadour: www.nadour.org

Universes-in-Universe: www.universes-in-universe.org

EOA Projects: www.eoaprojects.com

Traffic: www.viatraffic.org